brae

W9-BJL-070

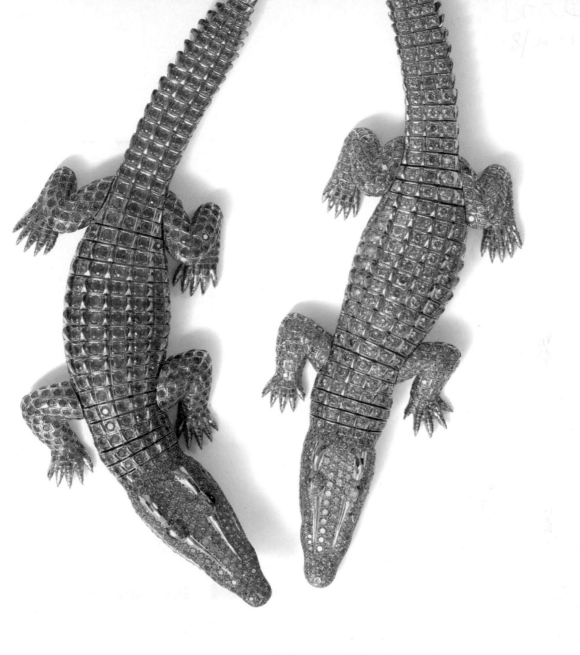

BEAUTIFUL
CREATURES

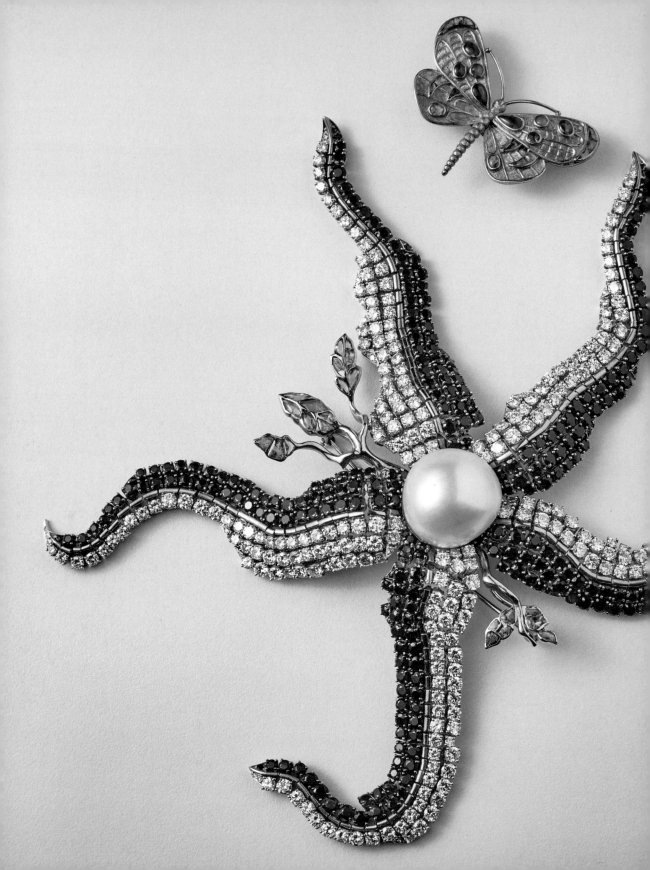

BEAUTIFUL CREATURES

Jewelry Inspired by the Animal Kingdom

MARION FASEL

Rizzoli **Electa** 150 YEARS | AMERICAN MUSEUM OF NATURAL HISTORY

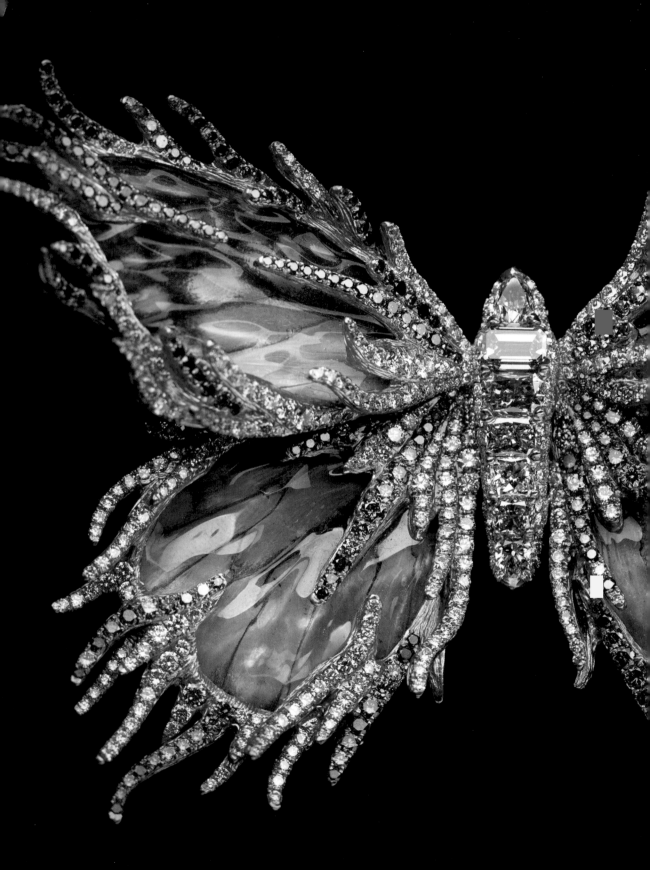

foreword

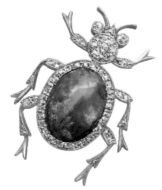

ABOVE Beetle Brooch, ca. 1905. Black opal, diamonds, and platinum.

SINCE TIME IMMEMORIAL, PEOPLE have adorned themselves with the products of the natural world, including the astonishing range of gems from our planet Earth. We have turned to the natural world not only for materials but also, frequently, for inspiration for the forms and figures of ornaments and jewelry.

This book showcases extraordinary jewelry inspired by animals—pieces in the form of fish, birds, butterflies, panthers, lizards, and even spiders and jellyfish—fashioned by jewelry artists from around the globe into beautiful, whimsical, and playful pieces using some of the world's most dazzling and spectacular gem specimens. They are all part of *Beautiful Creatures: Jewelry Inspired by the Animal Kingdom*, the inaugural special exhibition in the American Museum of Natural History's completely reimagined and renovated Allison and Roberto Mignone Halls of Gems and Minerals. Designed by Ralph Appelbaum Associates, the Mignone Halls of Gems and Minerals present more than 5,000 minerals from the Museum's world-renowned collection of more than 100,000 mineral and gem specimens, which tell the fascinating stories of the complex processes that gave rise to the extraordinary diversity of minerals on our dynamic planet and describe how people have used them throughout history for personal adornment, tools, and technology.

A key feature of the new Halls is a gallery dedicated to the presentation of special temporary exhibitions that enables the Museum to showcase new discoveries, exceptional pieces, and presentations on fascinating topics, including this exhibition exploring the intersection of geology, the animal kingdom, and human artistry and personal adornment.

The renovation of the Mignone Halls of Gems and Minerals is part of a wide range of capital and programmatic enhancements commemorating the Museum's 150th anniversary and culminating in the opening of the Richard Gilder

RIGHT Maximus Necklace by Van Cleef & Arpels, 2011. Fire opal, blue-green elbaite tourmaline, diamonds, yellow sapphires, spessartine garnets, blue sapphires, white gold, and yellow gold.

Center for Science, Education, and Innovation. This major new facility will house resources for education, exhibition, and research and reveal modern science to visitors of all ages. It will also, notably, link directly to the Mignone Halls of Gems and Minerals. As the opening of the Halls is a milestone in the Museum's 150th anniversary, it is fitting that all the pieces in *Beautiful Creatures* were created since the Museum's founding in 1869.

We are deeply appreciative of Allison and Roberto Mignone for their vision and generosity, which has made the Halls' renovation possible. And we acknowledge the generous support for the Halls from the Arthur Ross Foundation, with our thanks to Janet Ross.

I'd also like to thank curator George E. Harlow for his leadership in developing the Mignone Halls of Gems and Minerals; Museum provost Michael J. Novacek for his oversight of the Museum's scientific and exhibition activities; vice president for exhibition Lauri Halderman; and, of course, jewelry historian and curator Marion Fasel for developing this dazzling exhibition and book.

As the Museum has done decade after decade throughout its 150 years, the Mignone Halls of Gems and Minerals, this exhibition, and this book explore nature and culture by elucidating the science of our world, showcasing Earth's glorious diversity, and exploring the intersection between humans and nature and humanity's place in the larger scheme. We hope that this exhibition and book will inspire you to embark on a larger journey of discovery, at the Museum and beyond.

Ellen V. Futter
President
AMERICAN MUSEUM
OF NATURAL HISTORY

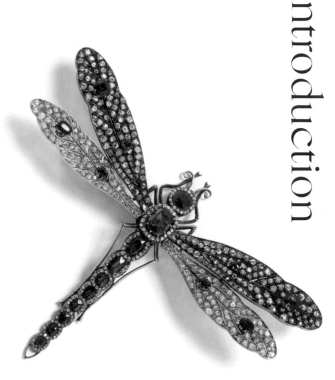

BUTTERFLIES, FISH, LIONS, BIRDS, and countless other creatures have been immortalized in fine jewelry for thousands of years. Snakes were ubiquitous in ancient Greek gold bracelets and rings. The master Moche goldsmiths of northern Peru made elaborate nose ornaments depicting shrimp in the 6th century. Felines, ferrets, and parrots can all be found in enamel and pearl Renaissance pendants. Animals have contributed striking silhouettes and a dramatic sense of narrative to jewelry. They have represented characters from mythology and spiritual beliefs and often appeared as amulets that embody specific traits associated with them.

This catalogue for the *Beautiful Creatures* exhibition is devoted to animal-themed jewelry designs created over the last 150 years. The timeframe dovetails with the founding of the American Museum of Natural History in New York in 1869, and the exhibition opening coincides with the Museum's 150th anniversary. The institution, and others like it around the world, actively contributed to the public's exposure to and subsequent fascination with the study and science of nature, particularly the animal kingdom. By the end of the 19th century, designers were responding en masse to that wave of enthusiasm with collections of realistic looking animal and insect jewels.

In the last 150 years, animal jewels have reflected a number of other cultural tides and historical events. The passion for fishing in America during the 1920s and 1930s led to a fashion for diamond fish brooches.

ABOVE Dragonfly Brooch, late 19th century. Sapphires, rubies, diamonds, silver, and gold.

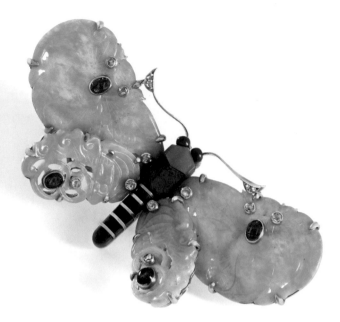

ABOVE Butterfly Brooch by Cartier Paris, 1944. Jadeite, rubies, diamonds, lapis lazuli, coral, and gold.

OPPOSITE Dolphin Brooch by Verdura, designed in 1945, made ca. 1995. Citrines, diamonds, emerald (eye), and gold.

With the occupation of Paris during World War II, bejeweled birds became symbols of hope. One of the factors that contributed to the increase in elephant, giraffe, and zebra jewels produced in the 1960s was the work of conservationists, who drew attention to the endangered mammals of Africa.

In the 20th century, certain animals turned into unofficial mascots of jewelry firms where they were made repeatedly and magnificently. Panthers have been part of Cartier's collections for more than 100 years. Birds became associated with Pierre Sterlé after the Frenchman designed a gigantic gold and gem-set flock during the midcentury. Bulgari's stunning snake watch-bracelets of the 1960s transformed serpents into an icon of the Italian firm.

Some of the most imaginative jewels of the modern era are one-of-a-kind treasures linked to personal narratives. A special-commission platinum and diamond Tiffany & Co. swordfish brooch made in 1927 commemorated esteemed angler Oliver Cromwell Grinnell's catch of the first broadbill swordfish with a rod and reel off the Atlantic coast. In 1939 the titled Italian designer Duke Fulco di Verdura bought pristine lion's paw shells from the American Museum of Natural History gift shop, took them back to his studio, and made them into brooches accented with diamonds and gold. Tiffany & Co. designer Jean Schlumberger helped ease the pain of his client Bunny Mellon's jellyfish sting in 1967 by designing her a brooch depicting the beast in moonstones, sapphires, diamonds, and gold.

The jewels in *Beautiful Creatures* are organized by the habitats of the animals they depict—air, water, and land—and subdivided within each section by type of creature. Placing animal jewels from different periods side-by-side for comparison demonstrates how styles and trends in gems and manufacturing have evolved over the years. After the late 19th-century discovery of diamonds in South Africa, butterfly brooches were designed in a monochromatic high jewelry style with the white gem. Around 1900, when the technology that allowed bench jewelers to work platinum was invented, new techniques were applied to jewels to enhance any number of effects, such as gossamer wings for dragonflies. In the 21st century, as jewelers learned how to manipulate titanium and transform it in a rainbow of colors, the metal was used in many opulent animal jewels by contemporary masters, including Wallace Chan, Glenn Spiro, and Stephen Webster.

For the most part, the jewels in *Beautiful Creatures* are focused on gems. They show how a designer studies specimens—like those found in the American Museum of Natural History's Allison and Roberto Mignone Halls of Gems and Minerals—and transforms them into jeweled arts. The vast majority of these jewels are full-bodied animals, as opposed to body parts. They mirror the animals found in the dioramas throughout the American Museum of Natural History. There are no caricatures of animals or animals dressed as people or outfitted in fanciful accessories—themes that have been a leitmotif in jewelry over the last century. Barnyard and domestic animals were also left out, since there are no parallel displays in the Museum.

There has never been a period in history when animal jewels were the dominant style, yet they have never gone entirely extinct either. The animal kingdom, in all its remarkable diversity, promises never to lose its allure for jewelry designers. *Beautiful Creatures* pays tribute to that persistent call of the wild.

Marion Fasel
Guest Curator

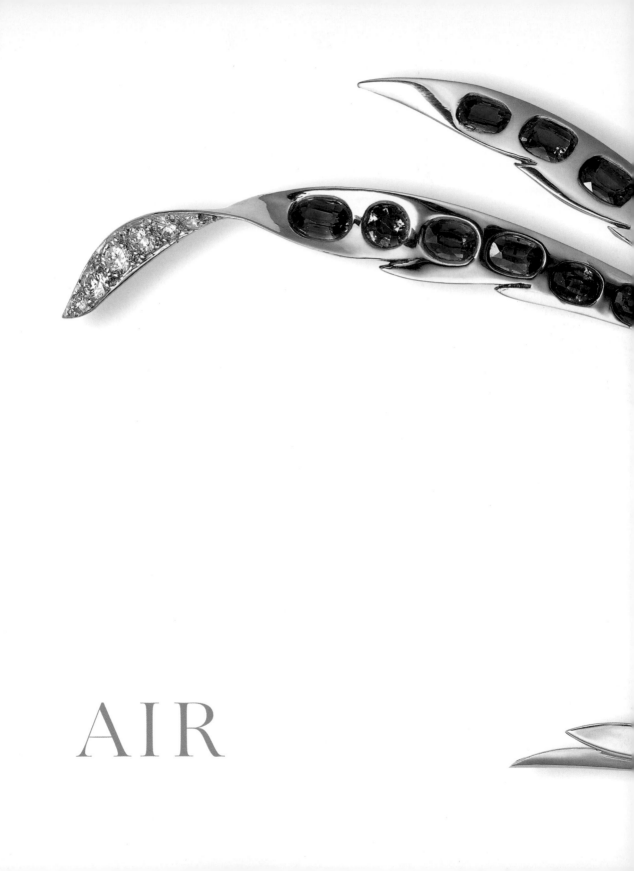

AIR

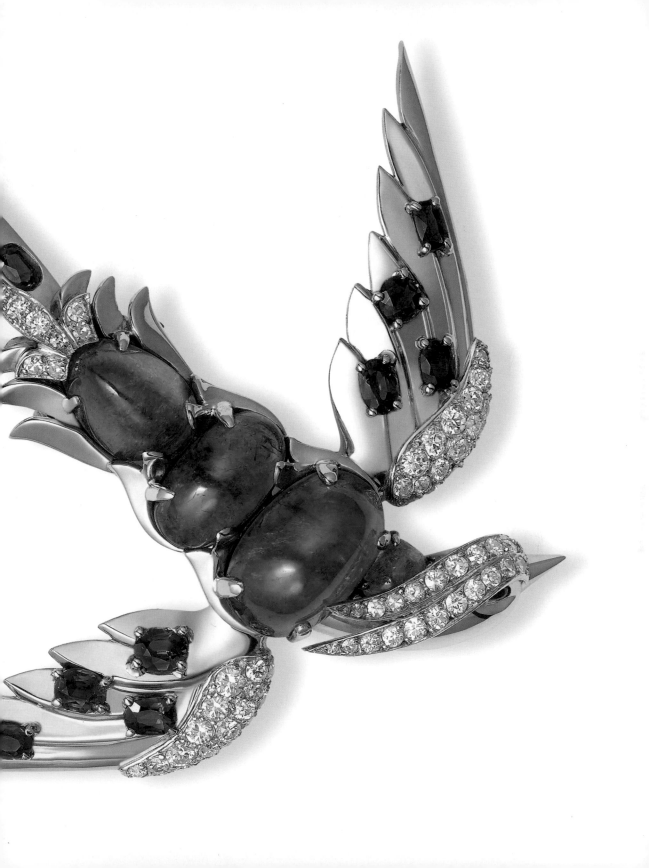

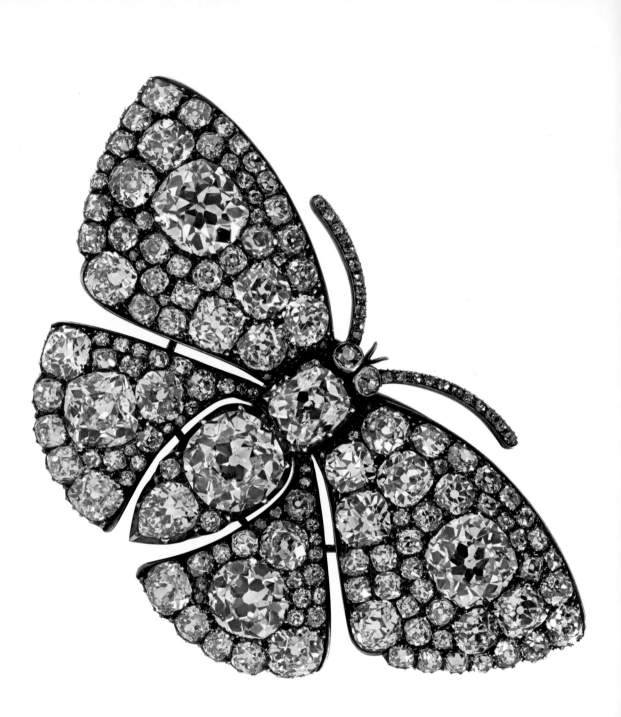

BUTTERFLIES HAVE BEEN among the most ubiquitous creatures in the animal jewelry kingdom over the last 150 years. The sheer beauty and symbolism of these insects are the main reasons for their consistent appeal. Another source of attraction for jewelry designers has been the butterfly's bold, graphic form—the insect's silhouette in jewels has not materially changed since the mid-19th century. Designs within essentially the same outline, however, are dramatically different. The wide flat surface of the four wings and the simple, linear body and antennae provide an ample canvas for artistic expression. Looking at a kaleidoscope of butterfly jewels made over time provides an extraordinary lens through which to see how jewelry techniques and the style for and available supply of gemstones have evolved.

The symbolic qualities attached to butterflies in the ancient era—love, life, and beauty—became meaningful again during the neoclassical revival of the 19th century and continue to resonate today. The philosopher Aristotle is believed to have been the first to call a butterfly a *psyche*—the ancient Greek word for soul. The term provided a connection to the romantic myth about the god Cupid and the princess Psyche, who is depicted in artworks and mosaics with butterfly wings.

The metamorphosis of a caterpillar into a butterfly links the creature to ideas of new beginnings and liberation. At times when people in the West have sought social change, butterfly jewels have spiked in popularity. One example of this occurred at the turn of the 20th century, when butterflies became an emblem of the American women's suffrage movement, and activists were referred to as Iron Butterflies. Some women wore small butterfly pins to indicate that they were fighting for the right to vote. The jewels were made of paste or real gems in the purple and green colors of the movement.

PREVIOUS SPREAD
Bird Brooch by Cartier Paris, 1944. Emeralds, sapphires, diamonds, rubies (eyes), gold, and platinum.

OPPOSITE Butterfly Brooch, European, ca. 1875. Diamonds (approximately 75 carats), silver, and gold.

OPPOSITE A late 19th-century portrait of Alexandra, Princess of Wales, wearing her diamond butterfly brooch near the shoulder of her bodice and a gold snake bracelet, as well as other diamond and pearl jewels.

IN THE 19TH CENTURY, the craze for butterfly collecting added immeasurably to the fashion for butterfly jewels. Designers made brooches and hair ornaments with colorful precious gems and plique-à-jour enamel wings. The high jewelry style was composed entirely of diamonds. While the monochromatic composition might seem at odds with the bright colors and patterns for which butterflies are beloved, it makes sense when considered in the larger context of jewelry. All-diamond jewelry was the dominant mode for formal designs.

The size of the gems in butterfly jewels became quite substantial when diamonds from the South African Kimberley Mine, which opened in 1871, made their way to the jewelry workshops of Europe and America. The large diamonds signified the importance of butterflies in a woman's jewelry collection.

One of the most high-profile figures to wear an impressive diamond butterfly brooch during this period was Great Britain's Princess Alexandra, who later became queen consort when her husband, Edward VII, ascended the throne in 1901 upon the death of his mother, Queen Victoria. Alexandra received her diamond butterfly in 1888 as a 25th wedding anniversary present. The British-made jewel measured almost four inches wide. Its wings had 46.78 carats of old mine cut diamonds set in silver with gold details. This jewel, like most butterfly brooches of the era, was animated by an *en tremblant* setting, which had small springs installed underneath the wings so that they would quiver slightly as the wearer moved.

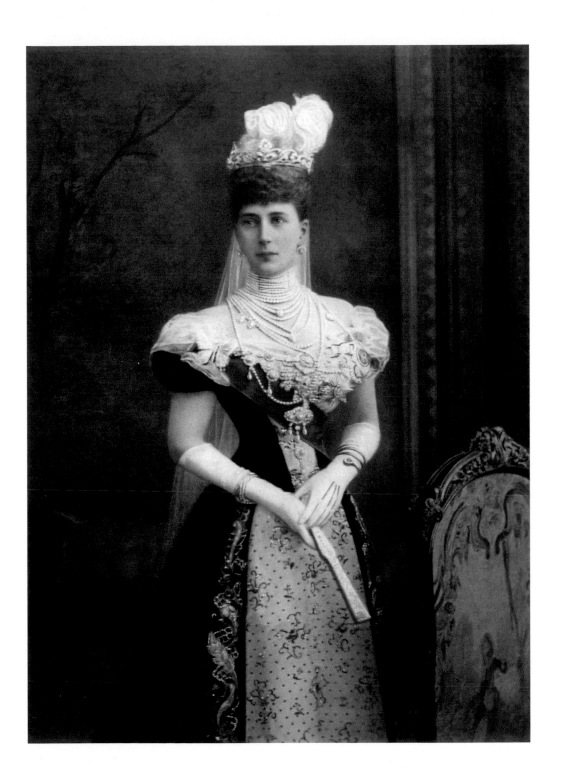

ABOVE LEFT Butterfly Brooch by Suzanne Belperron, ca. 1936. Multicolored sapphires, tourmalines, beryls, amethysts, enamel, and gold.

ABOVE RIGHT Pair of Butterfly Brooches by Suzanne Belperron, ca. 1955. Amethysts, yellow diamonds, citrines, and gold.

WHEN ABSTRACT geometric jewels came into vogue with the Art Deco movement of the 1920s, butterflies went into almost complete hibernation. During the Depression in the 1930s, a number of designers reintroduced naturalism with floral jewels and butterflies. These were a logical progression in the Van Cleef & Arpels collection of nature motifs, but insects were a surprise among the innovative designs of Suzanne Belperron.

Strong geometric shapes were a hallmark of Belperron's style from the beginning of her career in the 1920s, when she worked at René Boivin. The designer became more daring after she joined B. Herz in 1932; the firm eventually became known as Jean Herz-Suzanne Belperron. A year

after Belperron started, *Vogue* proclaimed that her "barbaric jewels" were characterized by a "weighty magnificence."

So why did the designer begin creating butterfly brooches, a comparatively light theme, in 1936? Butterflies were in the zeitgeist in France. In 1937, Belperron's friend, Elsa Schiaparelli, produced evening gowns with a butterfly print. Known as a Surrealist fashion designer, Schiaparelli most likely identified with the art movement's interest in the butterfly as a figure of metamorphosis. Another friend of Belperron's, the writer Colette, is believed to have given her the 1937 book *The Splendor of Butterflies*. If this is true, it would

seem Belperron had a personal connection to the insect. Perhaps she identified with the symbolism of liberation: in her new position at Herz, Belperron had total creative control, something she had not enjoyed at René Boivin, where she never received much recognition or appropriate compensation for her talents. Her butterfly designs may have represented this newfound freedom.

Remarkably, considering her design history, Belperron maintained the classic butterfly

BELOW LEFT Butterfly Brooch by Suzanne Belperron, ca. 1936. Rubies and gold.

BELOW RIGHT Butterfly Brooch by Suzanne Belperron, ca. 1936. Emeralds, yellow sapphires, rubies, diamonds, enamel, and gold.

BELOW Butterfly
Brooch by Suzanne
Belperron, ca. 1940.
Emeralds, diamonds,
gold, and platinum.

silhouette in her jewels. Yet the gems and goldwork on her butterfly brooches did not look like anything that came before them. Belperron's small gold butterflies had colorful gemstones. In some styles, wings were engraved with scaled patterns. Belperron's colossal gold butterfly brooches, measuring about six inches wide, had burnished set gems—flush with the metal—in a loose mosaic pattern.

Some giant Belperron butterfly wings displayed large stones in a slender bezel, or collar, of gold elevated slightly above the gems paving the surface.

Belperron's butterflies caused a sensation. In 1937 Dorothy Paley was spotted by *Harper's Bazaar* wearing a Belperron butterfly she received from her husband, CBS executive William S. Paley. Renowned jewelry collector Daisy Fellowes, the Singer sewing machine heiress, was seen wearing a Belperron butterfly brooch the same year, and many other women owned the dazzling insects. Belperron continued to design butterflies through the mid-1950s.

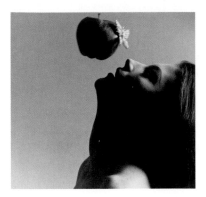

IN THE 1960S, butterflies were again popular, perhaps even more so than in the 19th century. Almost every big name in the jewelry business produced its own unique species. The initial phase of the revival expressed the same spirit that First Lady Jacqueline Kennedy embodied during her White House years: at state dinners she displayed a formal yet youthful quality and often paired pastel colored gowns with long white gloves and wore diamond brooches in her hair. While Mrs. Kennedy did not own a butterfly brooch, one would have fit nicely into her wardrobe.

One of the First Lady's favorite jewelers, Van Cleef & Arpels, made butterflies in the 1960s. Formal, feminine designs were the house's stock in trade. It was a look that attracted stylish clients, including Elizabeth Taylor, Grace Kelly, and Maria Callas. Woolworth heiress Barbara Hutton had a Van Cleef & Arpels butterfly brooch that epitomized the early 1960s style. The jewel is covered in diamonds and accented with both cabochon and faceted round emeralds. The body is prong set with three different sizes of emerald cabochons.

LEFT Italian actress Nicoletta Rangoni Machiavelli and an apple accented with a Bulgari diamond butterfly brooch. Photo by Joseph Leombruno for the January 1, 1964, issue of *Vogue*.

BELOW Butterfly Brooch by Van Cleef & Arpels, ca. 1965. Diamonds, emeralds, and gold. Formerly in the collection of Barbara Hutton.

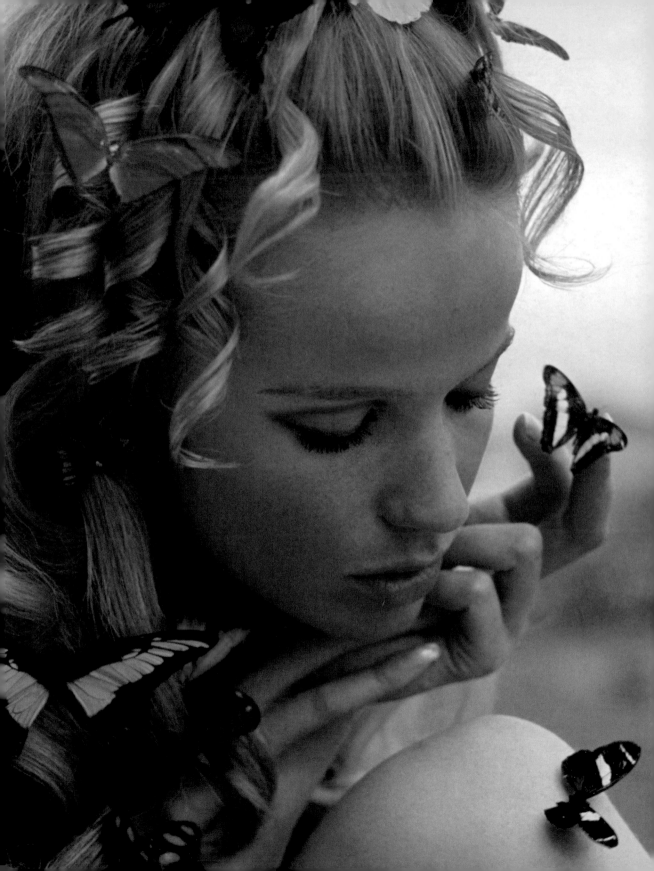

FROM THE LATE 1960S and into the 1970s, butterfly jewels were made in all kinds of colorful individualized styles, mirroring the newly liberated and relaxed looks of the day, such as miniskirts, bell bottoms, t-shirts, and jeans. Fulco di Verdura, the talented Italian duke behind the Verdura label, transformed the gems from a client's old piece of jewelry into a new butterfly brooch in 1969. Wings of twisted gold wire had ten cabochon moonstones and twenty round faceted sapphires nestled in the openings.

OPPOSITE Model Veruschka is surrounded by butterflies in Bahia, Brazil. Photo by Franco Rubartelli for the January 15, 1968, issue of *Vogue*.

ABOVE Butterfly Brooch by Verdura, 1969. Moonstones, sapphires, and gold.

ABOVE Butterfly
Earrings designed
by Donald Claflin for
Tiffany & Co., ca. 1972.
Diamonds, yellow
sapphires, tanzanites,
green tourmalines,
pink tourmalines, gold,
and platinum. Formerly
in the collection of
Mamdouha El-Sayed
Bobst.

TIFFANY & CO. designer Donald Claflin, who was known for his animal jewels depicting characters from children's literature, created double butterfly pendant earrings around 1969. While the jewels do not have a known narrative reference, the sweet pastel color scheme expresses a childlike innocence.

The little pear-shape tanzanites at the center of each were significant gems for Tiffany & Co. In 1967, shortly after the gem was discovered in a small mining area in Tanzania near Mount Kilimanjaro, specimens were shown to Tiffany's vice president Henry B. Platt, the great-great-grandson of the firm's founder Charles Lewis Tiffany. Platt saw the potential in the blue-violet variety of the mineral zoisite that was available in only one location in the world. He named it tanzanite and started buying the best examples. Donald Claflin designed Tiffany's first full collection using the gemstone in 1968 and continued to use it in other designs like these butterfly earrings.

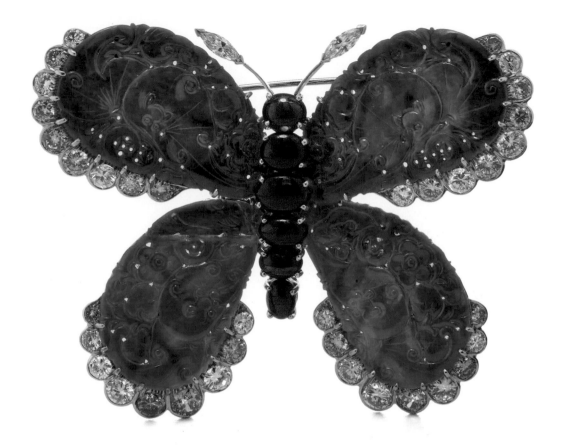

"JADE IS TODAY'S kind of jewelry," explained designer David Webb in the 1970s. Clearly, the American talent also believed butterflies were of the moment, because he included them in his jade collection. Most of the carved jadeite Webb used was extracted from antique jewels found at secondhand shops in New York City. Square and rectangular pieces of jadeite were set in brooches with elaborate gold and diamond frames. Jadeite in organic teardrop shapes became butterfly wings in brooches. This astounding butterfly made by Webb in 1972 has carved jadeite wings outlined in sections by white diamonds set in a doily pattern of gold. The body is composed of six cabochon rubies. Marquise-shape diamonds form the ends of the antennae.

ABOVE Butterfly Brooch by David Webb, 1972. Jadeite, rubies, diamonds, and gold.

IN THE 1980S, butterflies were the signature motif of the JAR jewelry collection created by Joel Arthur Rosenthal. The insect reflected the designer's interest in late 19th-century jewelry. Materials used in that period—hand-cut diamonds, an array of colorful semiprecious stones, and blackened silver—were also part of his oeuvre. Rosenthal masterfully combined Victorian-era elements with his modern sensibility and in the process created a new vocabulary for jewelry.

A native New Yorker and a Harvard graduate, the designer dabbled in writing screenplays, hand-painted embroidery, and did a stint at Bulgari before he opened the JAR boutique at 7 Place Vendôme in Paris in 1977 with his partner, Pierre Jeannet. Rosenthal's jewels attracted attention almost immediately because they were so different from the prevalent hulking styles set with big precious stones.

The signature look of the designer's jewelry is beautifully demonstrated in this brooch from 1987. The wings have a selection of light to dark blue-purple Montana sapphires divided by veins of white diamonds. Rose-colored diamonds, surrounding a 3.89-carat antique cushion-cut diamond, cover the body of the insect. The metal mounting is a critical part of the butterfly's pavé. Rosenthal used platinum sparingly to brighten the diamonds on the veins of the wings. Blackened silver makes up the majority of the mounting. A standard in Rosenthal's work, blackened silver was totally unorthodox in the 1980s. Fine jewelers had stopped using silver about 100 years earlier, when they gained the technology to work with platinum, which heightens a gem's brilliance. Rosenthal, however, was not seeking that traditional effect. He preferred the matte finish of blackened silver for its dramatic appearance. The metal contrasted with the white diamonds and outlined the various shades of the Montana sapphires. It gave Rosenthal's pavé a nubby appearance that harkens back to his experience in embroidery.

OPPOSITE Butterfly Brooch by JAR, 1987. Montana sapphires, diamonds, pale pink diamonds, platinum, silver, and gold.

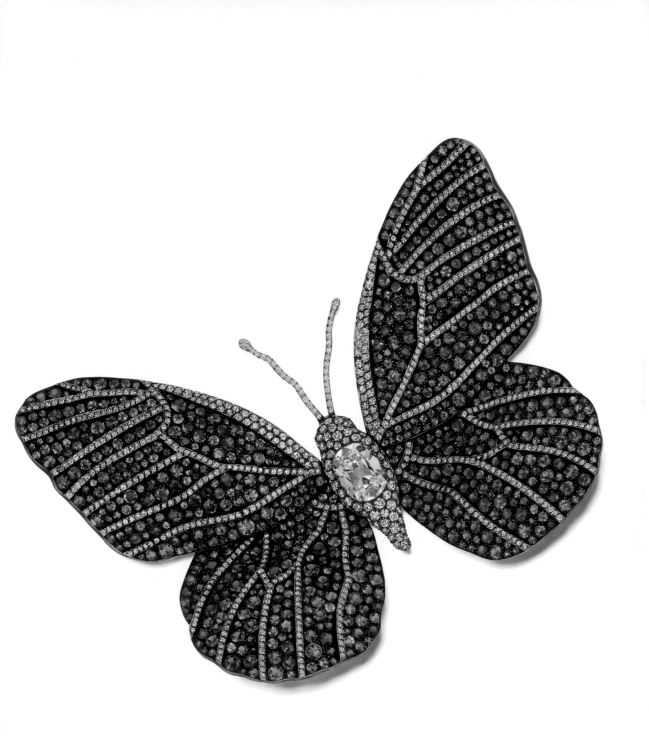

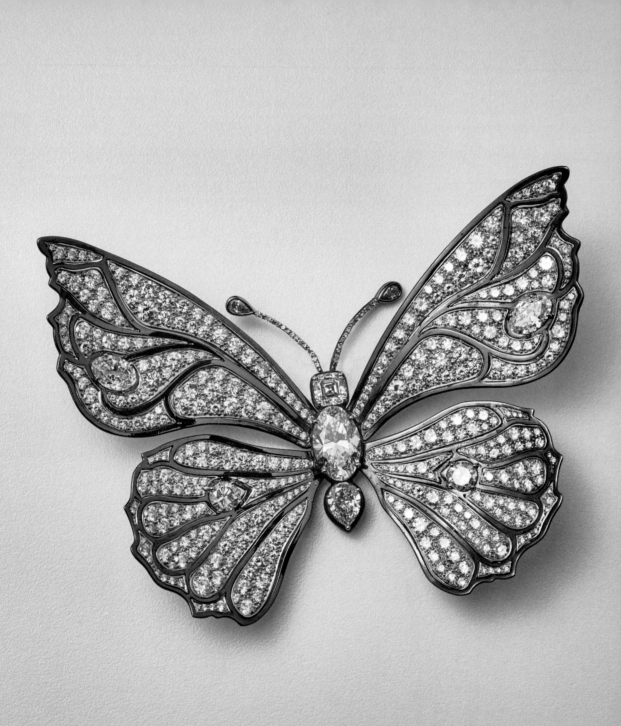

THE BUTTERFLY BROOCH Ralph Esmerian and André Chervin collaborated on in the mid-1990s was among a small number of pieces the industry insiders made together as elevated creative exercises. At the time the butterfly was created, Esmerian, a fourth-generation dealer in colored gemstones, was running the business R. Esmerian, Inc. His father, Raphael, had established the company in New York City in 1940 after emigrating from Paris. In addition to purveying gems to jewelers such as Cartier, Tiffany & Co., and Van Cleef & Arpels, Esmerian sold the finest jewels dating from the late 19th to the mid-20th century. He also put together a unique collection of jewels from the same periods; it was considered by many to be one of the finest ever assembled.

Chervin, who came from a family of French jewelers, relocated to New York at the end of World War II. In 1954 he established Carvin French with his business partner, Serge Carponcy. (Carvin was a combination of the men's last names, and French was a tribute to their native country.) Carvin French's clients were the same set of esteemed companies that purchased precious stones from Esmerian.

The genesis for the idea of the butterfly brooch was a sensational lot of yellow diamonds that Esmerian acquired. He showed them to Chervin and shared his interest in using stainless steel as the foundation for a butterfly. Esmerian says, "I became fascinated by the industrial metal from an 1880 Lucien Falize bracelet with a mythological theme composed of steel with gold details and diamond highlights."

Chervin and Esmerian worked over the design of their butterfly and elements of the manufacturing for months. One amazing detail is the thinness the craftsmen at Carvin French were able to achieve with articulated oxidized stainless steel wings to lessen the weight of the metal. They then pavé-set the wings with gems. The body of the insect has a 1.23-carat square-cut fancy intense yellow diamond, a 5.01-carat oval-cut fancy vivid yellow diamond, and a 1.33-carat pear-shape fancy vivid yellow diamond. The antennae are mounted with pear and circular-cut yellow diamonds.

OPPOSITE Butterfly Brooch by Ralph Esmerian & Carvin French for R. Esmerian, Inc., 1997. Yellow diamonds, gold, and stainless steel.

OPPOSITE Forever
Dancing—Bright
Star Brooch by
Wallace Chan, 2013.
Colored diamonds,
crystal, mother-of-
pearl, titanium, and
butterfly specimen.

"BUTTERFLIES ARE PART of my childhood, my culture, and my heart," explained master jeweler and designer Wallace Chan in his 2016 monograph *Dream Light Water*. "At about eight or ten years old, I went to the cinema for the first time and saw *The Butterfly Lovers*." The film is regarded as a Romeo and Juliet story for the East. After the lovers die, they become a pair of butterflies flying out from the grave. "Nature completed their love and made it eternal," says Chan. "Since then butterflies have meant eternal love for me."

One of the greatest independent high jewelers of his generation, Chan grew up in extreme poverty in the southeastern Fujian Province in China. After a childhood spent honing his skills at handicrafts, in 1974—when he was just seventeen—he set up his own jewelry workshop, which became renowned for innovative creations inspired by mythology and nature.

The Forever Dancing—Bright Star brooch is made of substantially sized and uniquely shaped brown diamonds set in green titanium on the body. Real butterfly wings are mounted between crystal and mother-of-pearl. Brown and white diamonds set in green titanium on the contoured edges suggest the movement of flight.

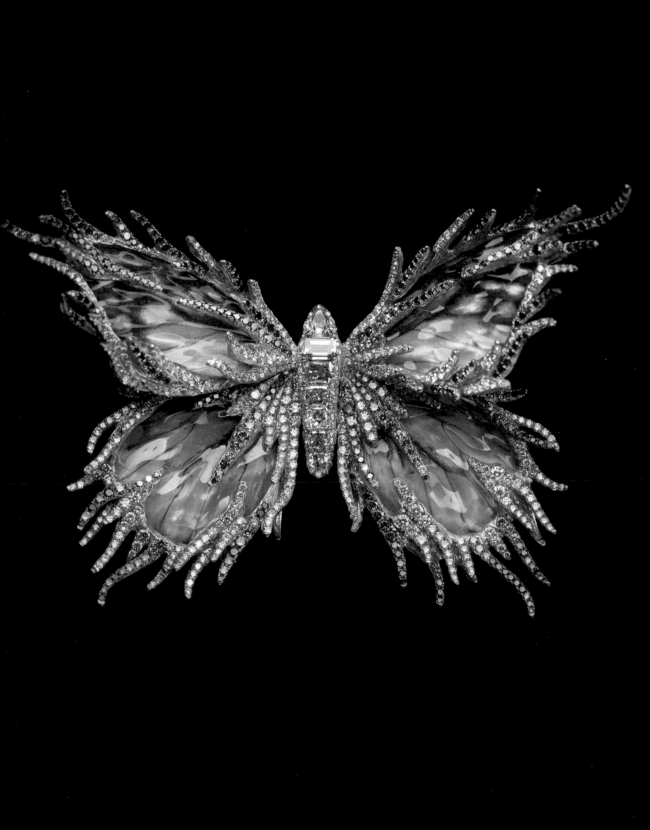

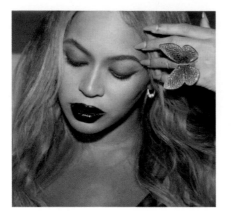

ABOVE Beyoncé wearing a G by Glenn Spiro Papillon ring in a photo taken by Jay-Z.

OPPOSITE Papillon Ring by G by Glenn Spiro, 2019. Colored diamonds, diamonds, titanium, and red gold.

GLENN SPIRO MADE the mechanical Papillon ring for his G by Glenn Spiro collection to celebrate his design debut in 2014, after decades of working behind the scenes in the jewelry world. The jeweler began his career when he left school at just fifteen years old to apprentice at English Artworks, a Cartier workshop in London. Several years later he became a jewelry specialist at Christie's but eventually returned to manufacturing for prestige brands. Finally, at age 51, the jewelry veteran decided to design his own collection. The jewels focused on stunning gems in dynamic shapes and a few floral pieces.

Harrods in London launched the line, and for the celebration, Spiro created his own rendition of a butterfly, a motif he had long loved. He wanted to conjure something with much more movement than a traditional *en tremblant* setting and realized a butterfly ring could be animated by gestures of the hand if it was crafted using a spring system on the parts wrapped around the finger. "It took months of work, as our focus was that it not only looks lightweight but that it also felt lightweight for the wearer," explains Spiro. "The light weight of titanium made it all possible." Since the metal can be anodized in various colors, it also became possible to match or contrast the setting with the array of pavé-set stones Spiro used.

Jay-Z and Beyoncé acquired a Papillon ring covered in a pavé of emeralds mixed with tsavorites. The gradient pattern of greens is outlined with a line of white diamonds set against a blue titanium background. In 2018, Jay-Z and Beyoncé donated the ring to the Victoria & Albert Museum in London, where it is on permanent display.

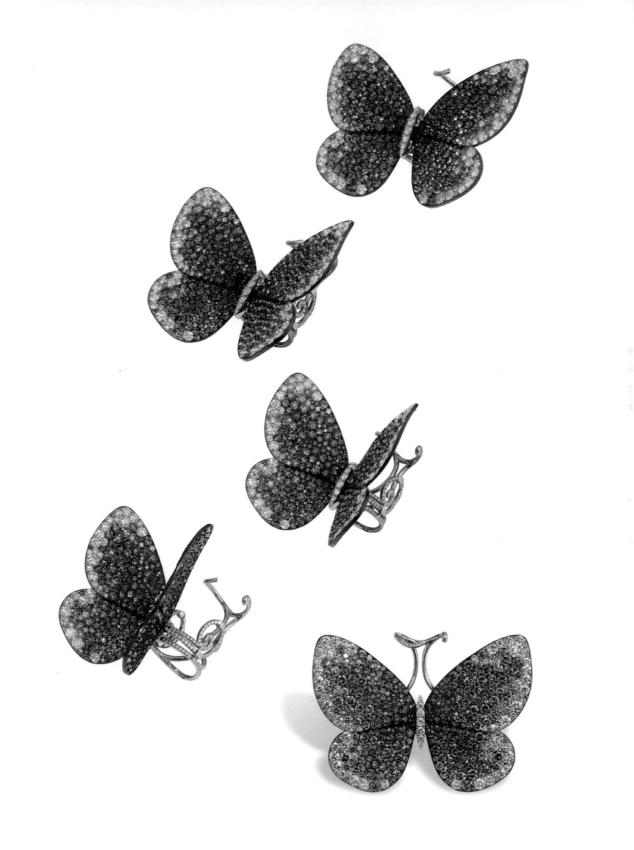

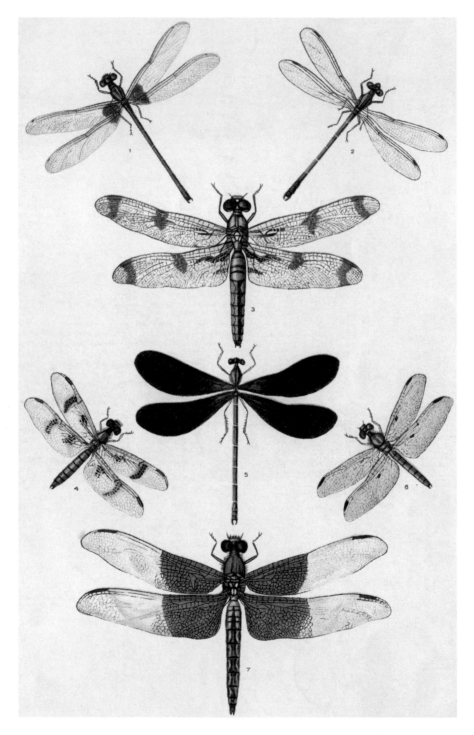

dragonflies

DRAGONFLY JEWELS came into vogue in the West after trade with Japan reopened in 1853. For thousands of years, the insects had been admired by the Japanese as cunning creatures and symbols of summer and autumn. Dragonflies were depicted on many of the nation's exports, including the decorative objects, woodcuts, lacquers, and silk kimonos that were seen by millions when they went on display at the 1862 International Exhibition in London and the 1867 Exposition Universelle in Paris. The first dragonflies to fly into the European and American jewelry worlds were a tribute to Japanese style.

OPPOSITE An illustration of dragonflies from *New International Encyclopedia* (1902), top row, left to right: red-spotted damselfly, green-bodied damselfly; second row: bandoo dragonfly; third row: female amberwing, blackwing, male amberwing; fourth row: basal dragonfly.

ABOVE Dragonfly Brooch by Boucheron, ca. 1890. Diamonds, enamel, gold, and platinum.

AT TIFFANY & CO. in New York City, dragonflies debuted in Japonisme tableware around 1878. Silver trays and pitchers displayed scenes of dragonflies with copper bodies and applied gold wings flying among botanical motifs. Some years later, dragonflies began to appear in Tiffany's jewelry collection. One elegant dragonfly brooch, made around 1890, had *en tremblant* diamond wings with gold veins and specially cut sapphires interspersed with diamonds on the elongated abdomen. A cabochon sapphire surrounded by diamonds formed the thorax. Sapphires composed the eyes. Gold made up the jointed legs and antennae. Like most brooches from this period, the dragonfly was intended to be worn on a bodice or in the hair.

LEFT Dragonfly Brooch/ Hair Ornament by Tiffany & Co., ca. 1895. Diamonds, sapphires, gold, and silver.

OPPOSITE Dragonfly Clip Brooch by Cartier Paris, 1953. Diamonds, rubies, emerald, platinum, and gold.

AFTER THE TURN of the 20th
century, dragonflies, like so many
creatures that were popular during
the period, became a traditional
motif in jewelry. One of the many
dragonflies Cartier created during
the 1950s had calibré-cut rubies
on the abdomen, round faceted
ruby eyes, and an emerald thorax.
Each of the diamond forewings and
hindwings were set *en tremblant*,
so as to flutter at the slightest
touch or movement.

PAINTER, GLASSMAKER, and interior designer Louis Comfort Tiffany, the son of the Tiffany & Co. founder, Charles Lewis Tiffany, was inspired by the Japanese art he saw at the 1867 Exposition Universelle in Paris. In 1899 his design studio produced a stained-glass leaded dragonfly lampshade, one of the most popular styles. When Louis Comfort became design director of Tiffany & Co. in 1903, several dragonfly jewels were made under his direction.

Julia Munson, a talented member of Tiffany's team, designed a series of magnificent dragonflies in 1904. The styles centered on black opals, gems that echoed the iridescence of the insect. Other gems on the dragonflies in the series included green demantoid garnets and pink opals. The openwork platinum wings were astonishingly detailed.

Platinum became fully incorporated in jewelry around 1900. Up to that year, it had been used only occasionally, because torches could not achieve the levels of heat required (greater than 3,200 degrees Fahrenheit) to melt the metal. Before apt torches were developed, platinum had to be laboriously chiseled. Once the technology improved, jewelers began shaping platinum into delicate curls, swirls, wires, and millegrain. Tiffany used platinum in an entirely different way on its dragonfly: it outlined the veins on the wings. To show off the unusual platinum work, the wings were not set with any stones.

Several of the dragonflies from the Tiffany & Co. collection were exhibited at the 1904 Louisiana Purchase Exposition in St. Louis, Missouri. One hair ornament had two dragonflies alighting on dandelion clocks. (It is in the collection of the Metropolitan Museum of Art.) *The Jewelers' Circular* (October 26, 1904) described the wings on these dragonflies as made of "a special metal, spun and drawn to the fineness of a spider thread, and then so delicately woven in the structural lines of the wings that it gives an impression of the natural ones having been taken from its natural body and joined to a counterfeit resemblance."

OPPOSITE Dragonfly Brooch designed by Julia Munson under the direction of Louis Comfort Tiffany for Tiffany & Co., 1904. Black opals, demantoid garnets, platinum, and gold.

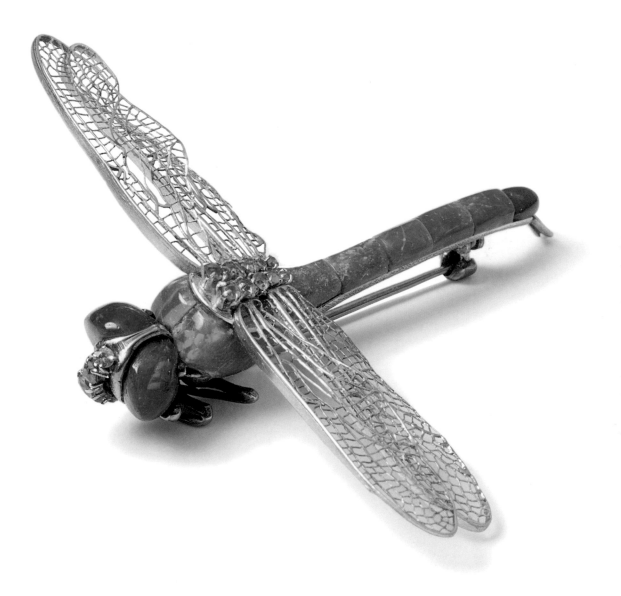

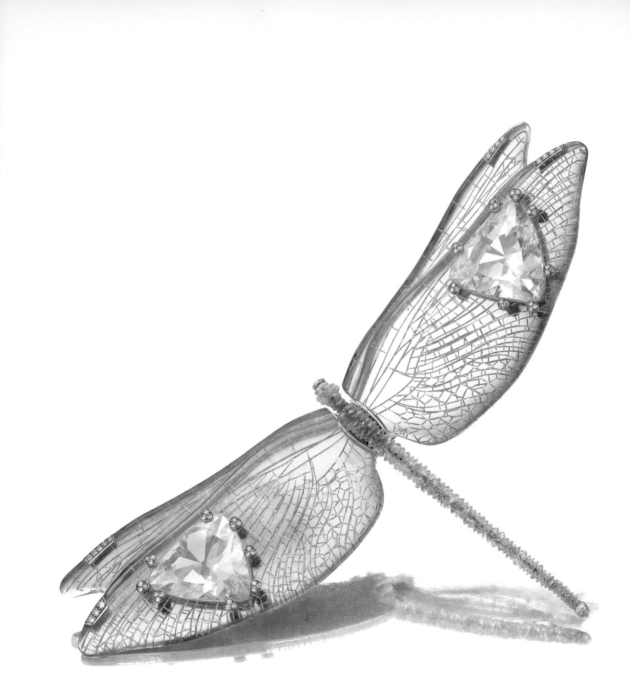

JOEL ARTHUR ROSENTHAL, the creative force behind the JAR jewelry collection, has designed only a few dragonflies over the course of his illustrious career. One he made in 1987 exhibits an appreciation for late 19th-century jewelry themes and showcases his creativity with precious materials, both facets of his work that can be traced back to his childhood. In a 2013 interview with *Financial Times* journalist Vanessa Friedman, one of the few Rosenthal has ever granted, the jeweler said that while growing up in New York City he spent a lot of time at the Metropolitan Museum of Art and the American Museum of Natural History "looking at the metals and minerals galleries."

The wings on Rosenthal's dragonfly are an astonishing combination of gems and techniques. They are composed of rock crystal and gold-wire veins.

A sheet of gold is set behind the wings to make them sparkle. Triangular shaped diamonds highlight the tips of the forewings. The abdomen, thorax, and head are entirely composed of faceted diamond rondelles. Considered one of JAR's most artistic jewels, the dragonfly was included in the designer's 2002 exhibition at the Gilbert Collection in London and the landmark 2013 *Jewels by JAR* exhibition at the Metropolitan Museum of Art.

OPPOSITE Dragonfly Brooch by JAR, 1987. Diamonds, rock crystal, gold, and silver.

ABOVE A 19th-century gem-set and enamel dragonfly brooch is pinned to the hat on the branch above the model's head. Photo by Horst P. Horst for the April 1, 1948, issue of *Vogue*.

FRED LEIGHTON became a major player in the creation of the estate jewelry market in the 1980s, generating new enthusiasm for the beauty of period pieces, which had previously fallen out of favor. By the 1990s, Leighton's following was international, and countless celebrities wore his vintage pieces on the red carpet. Motivated by his newfound fame, he conceived a contemporary collection inspired by the vintage inventory in his New York City boutique. One of his most popular creations was a diamond dragonfly that was much larger than its antique predecessors. Several of Fred Leighton's loyal clients acquired dragonfly brooches. One rendition made a memorable appearance at the 1998 Oscars, when Sharon Stone pinned it to the backside of a long lavender silk Vera Wang skirt that she paired with a white button-down shirt from the Gap.

BELOW Dragonfly Brooch by Fred Leighton, 1999. Diamonds, sapphires (eyes), and gold.

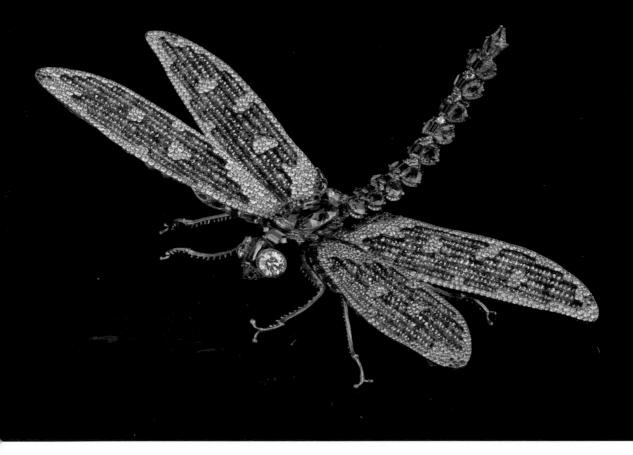

"**DRAGONFLIES ARE** constantly working out complex calculations, not through numbers, but through their movements," says Wallace Chan. "They calculate the strength needed to lift them to different heights, overcoming obstacles." Chan paid tribute to this insect's "calculations" through the wings on his Soaring Spirit brooch. The diamond beads on titanium threads are intended to resemble an abacus. Chan formed the body with vibrant green titanium. The metal complemented the tsavorite garnets on the abdomen and contrasted with the pink sapphires. Diamonds highlight different places all over the jewel. The body of the dragonfly quivers gently with the movements of the wearer to, as Chan describes it, "make the piece more alive."

ABOVE Soaring Spirit Brooch by Wallace Chan, 2017. Tsavorite garnets, diamonds, colored diamonds, rubies, pink sapphires, and titanium.

bees, beetles, cicadas, and flies

BEAUTIFUL BUTTERFLIES and dramatic dragonflies are not the only insects depicted in jewelry—bees, beetles, cicadas, flies, and many other insects have also been models for precious creatures. In the late 19th century, insect accessories reached the peak of their popularity. Jewelers were responding to the general public's obsession with insects that they had learned about through displays at museums of natural history and gorgeously illustrated books. Some amateur enthusiasts even assembled and studied their own insect collections at home. They saw the beauty in the little animals. For their part, designers recognized the jewel-like quality in even the most menacing looking species. Insect jewels were so fashionable that they eventually became part of the regular repertoire of jewelry motifs. The bejeweled creatures transitioned from lifelike to more artistic in later years, but they were all descendants of the original generation of jewels that paid tribute to the discoveries made by entomologists.

OPPOSITE Fly Pin by Tiffany & Co., 1880–1910. Diamonds, ruby, gold, and platinum.

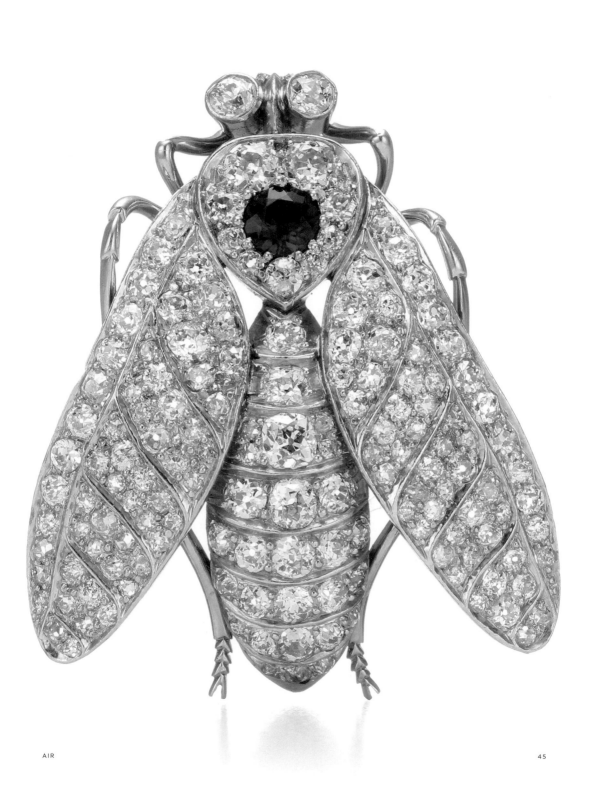

SMALL INSECT PINS, known as "scatter pins" because women liked to wear several scattered about their necklines, were among the offerings from Tiffany & Co. at the turn of the 20th century. The little jewels demonstrated how well the founder, Charles Lewis Tiffany, understood the diverse styles, not to mention price ranges, that Americans wanted to see in his store. The insects also showed how the talent of the firm's designers extended to small-scale items.

A magnificent bee pin made by Tiffany & Co. around 1895 has a pear-shape pearl abdomen, ruby eyes, a rose-cut diamond thorax, sculpted gold legs, and pavé-set diamond wings arranged at an angle, as though in flight. One charming little diamond fly pin made after 1880 has a ruby accent on the thorax and jointed legs made of gold (page 45). While the physical shapes of these jewels were clearly an attempt at realism, the gems did not reflect the colors of the insects in nature. Diamonds, pearls, and rubies were simply the most fashionable gems of the era.

A beautiful leaf weevil brooch made by Tiffany & Co.

in 1893 was a more true-to-life representation. It was among the hundreds of items Tiffany displayed at the 1893 World's Columbian Exposition in Chicago, Illinois. As at every grand world's fair during the era, exhibitors created fantastic presentations to impress the millions of attendees. The leaf weevil may have been one of the smaller pieces in Tiffany's collection, but there is no doubt it was noticed. Stunning emeralds covered the back and the head of a sculpted gold body.

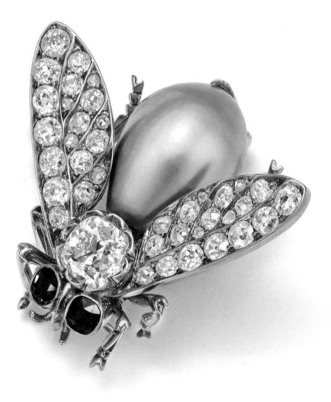

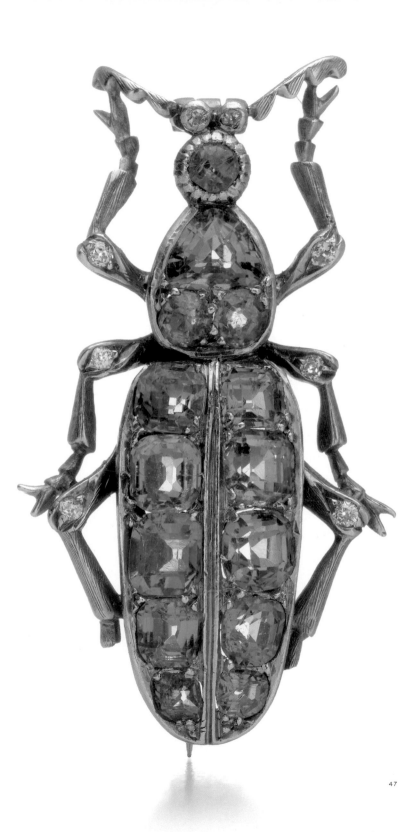

OPPOSITE Bee Pin by Tiffany & Co., ca. 1895. Diamonds, pearl, rubies (eyes), and gold.

RIGHT Leaf Weevil Brooch by Tiffany & Co., 1893. Emeralds, diamonds, and gold.

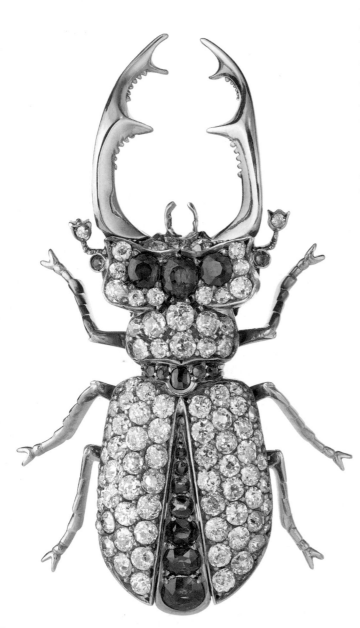

THE INSECTS CREATED by Boucheron at the end of the 19th century displayed the jeweler's creativity and technical prowess. In 1890 the firm made a fearsome large male stag beetle brooch that was the antithesis of romantic butterfly jewels. It measures almost three inches long and has dangerous looking gold mandibles and legs. Diamonds and rubies form the creature's glamorous exoskeleton. The jewel has a removable pin on the back, making it possible to wear it as a pendant, hair ornament, or brooch.

Boucheron created a very limited series of cicadas around 1895. Each was slightly different in size and in a unique position. The bodies included jointed gold or diamond and silver legs, diamonds set in silver on the abdomen and head, and sapphires on the thorax; faceted sapphires or chrysoberyl cat's eyes formed the eyes. The veined wings were composed of plique-à-jour enamel and gold. An *en tremblant* mounting made the wings flutter with the movement of the wearer.

LEFT Stag Beetle Brooch by Boucheron, ca. 1895. Diamonds, rubies, gold, and white gold.

OPPOSITE Cicada Brooch by Boucheron, ca. 1895. Diamond, sapphire, and chrysoberyl cat's eyes (eyes), enamel, gold, and silver.

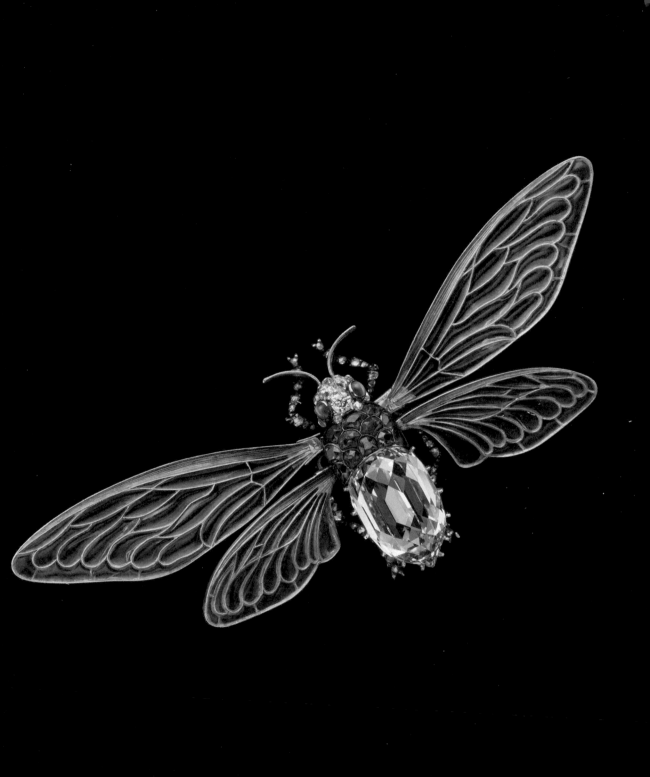

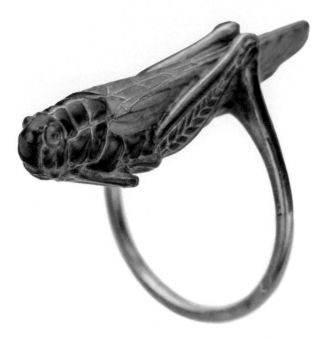

INVENTIVE RENDITIONS of insects can be found in Art Nouveau jewelry. Around 1895, the style was developed by a group of French designers intent on breaking away from traditional diamond jewelry with innovative pieces based on the organic shapes of nature and artfully rendered in sophisticated enamel highlighted with precious and semiprecious stones. Art Nouveau insects were often portrayed exotically: for example, an insect with the body of a nude woman and butterfly wings represented the idea of metamorphosis. Other jewels in the style depicted full-bodied insects in a more realistic manner.

A ring by Lucien Gaillard is so lifelike that when worn it appears as though a grasshopper has landed on the wearer's finger. The designer, who trained from a young age with his family of goldsmiths, added realistic curves to define all the body parts, legs, and wings. Brown enamel covers the head and long legs; green enamel wings stand out as a separate element. The eyes are bright cabochon emeralds.

ABOVE Grasshopper Ring by Lucien Gaillard, ca. 1900. Enamel, emeralds (eyes), and gold.

OPPOSITE Wasp Brooch by Van Cleef & Arpels, 1926. Diamonds, onyx, and platinum.

THE WASP BROOCH made by Van
Cleef & Arpels in 1926 is one example
of how the jeweler masterfully
reconstructed naturalism in the Art
Deco mode, something few others
did. Established in 1906, Van Cleef
& Arpels vaulted to the top of the
competitive French jewelry world
when it won a grand prize at the 1925
Exposition Internationale des Art
Décoratifs et Industriels Modernes,
the exhibition that officially
launched the Art Deco movement.
Among the displays of abstract
geometric-themed jewels, Van
Cleef & Arpels presented pieces
with a rose motif. Specially cut buff-
top ruby petals, emerald leaves, and
onyx thorns made the flowers look
at once modern and organic.

Around the same time, Van
Cleef & Arpels employed special
gem cuts to make a limited series
of wasp brooches look equally
modern. Each insect is poised in a
unique position and has a marquise-
cut diamond head and a diamond
body with calibré-cut onyx stripes.
The most eye-catching detail on
the small jewels are the wings,
which were assembled like puzzles
composed of an assortment of
table-cut diamonds. The flat gem
shape ingeniously suggests the
transparent veined wings of a wasp.

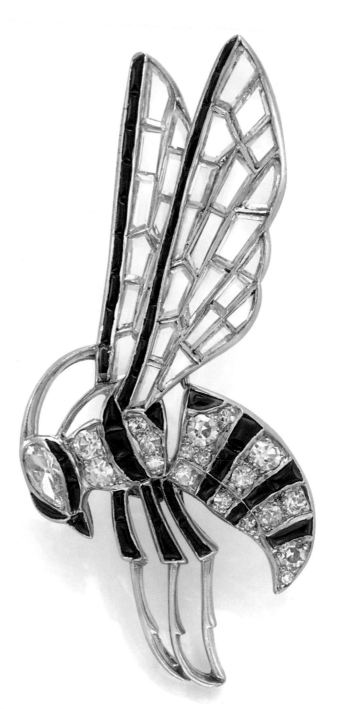

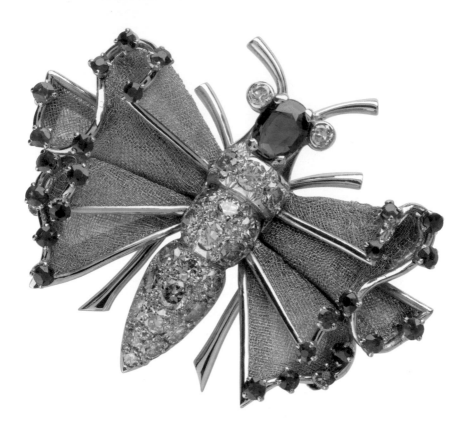

OVER THE YEARS, bejeweled insects have been rendered naturalistically, as well as in ways that reflected overarching trends. In the 1940s, insects were playfully made in the prevailing gold jewelry style with industrial looking elements. Although gold jewelry has no function other than to adorn, many designers glorified industry in their work as a sign of recovery and progress. It was a fresh way to express modernity.

Gold bolter mesh was used on the wings of an insect made by Boucheron in 1944. The material was lit up with little diamonds. Calibré-cut sapphires in horizontal bands were set across the thorax and abdomen. The same types of materials can be found on a bee clip produced by Van Cleef & Arpels in 1946. To suggest movement, the jeweler folded over the mesh on the wings and accented the ends with round sapphires. Yellow diamonds cover the abdomen, thorax, and eyes. A blue sapphire forms the head. The antennae and legs are composed of sleek shiny gold.

ABOVE Abeille Clip by Van Cleef & Arpels, 1946. Sapphires, yellow diamonds, and gold.

OPPOSITE Insect Clip by Boucheron, 1944. Sapphires, diamonds, and gold.

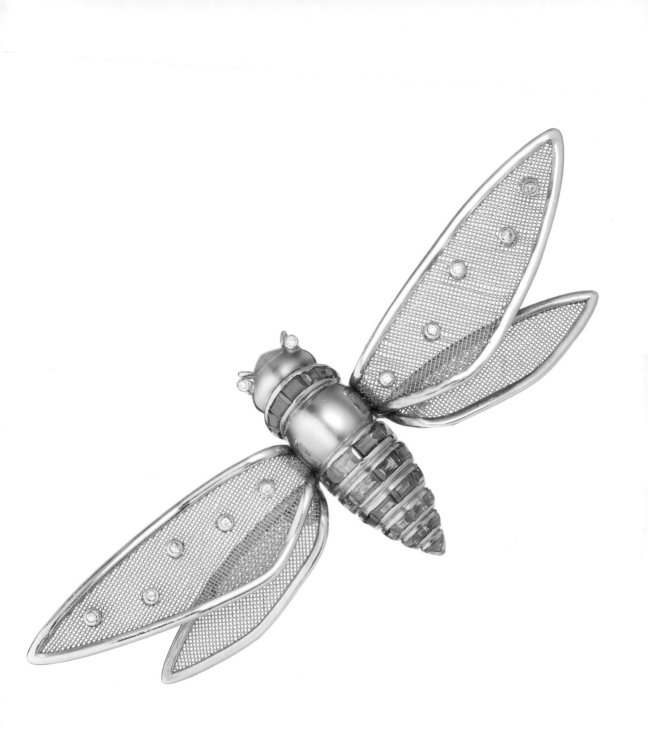

birds

SYMBOLS OF GLAMOUR and freedom, birds have soared through jewelry since the late 19th century. They were made throughout the Western world, but particularly beloved in France. Over time, designers created both jewels that reflected actual species and those that were fantastical amalgams of heads, crests, bodies, and tails from a variety of birds. The best examples are as boldly flamboyant as peacocks—showpieces that gave designers an opportunity to strut their expertise.

Bird jewels reflected a general interest in ornithology that grew throughout the 19th century. Beautifully illustrated books about birds by naturalists John James Audubon and Jules Pierre Verreaux became bestsellers. Members of society enjoyed birdwatching, and some even maintained aviaries.

OPPOSITE Bird Aigrette, ca. 1880. Diamonds, emeralds, sapphires, enamel, gold, and silver.

Birds in paradise—the poetic name given to collections of bird taxidermy displayed on tree branches—were prevalent in well-appointed homes.

· • · • ·

JEWELRY DESIGNERS analyzed birds at natural history museums and in zoos. Realistic sketches of birds in the archive of Chaumet, a French jeweler located on the Place Vendôme in Paris, reveal how seriously the in-house artisans studied. The research resulted in fantastical bejeweled hair ornaments called aigrettes. Often an aigrette had a special segment under the tail where the wearer could attach a plume of feathers that soared above her head.

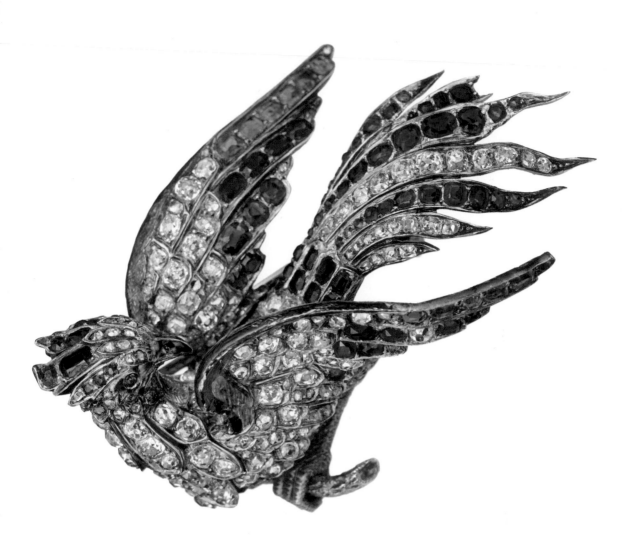

In 1906, Mellerio took a special order from the Maharaja Jagatjit Singh of Kapurthala for an aigrette in the shape of a large peacock, a revered bird in India. Blue, green, and yellow enamel decorated the bird's body, and elaborate openwork diamond tail feathers with enamel eyes curled in an arc to one side. The maharaja probably wore the peacock as a turban ornament. His wife, the Spanish flamenco dancer Anita Delgado, whom he married in 1908, would sometimes pin the jewel in her hair.

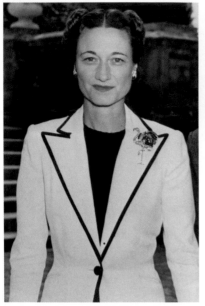

DURING WORLD WAR II, birds symbolized hope in France. The creatures were in high contrast to the dark reality of the conflict and the depressed jewelry business. During this time, access to a steady supply of precious gems was interrupted, and the vast majority of platinum, a vital strategic metal, was siphoned off and used by the military as a catalyst for fuel and explosives. Wartime shortages led to stiff regulations over the manufacture of French jewelry: a client was required to provide their own gold or platinum for jewels.

Despite the restrictions, or perhaps because of them, Parisian jewelers made some remarkable

birds during this time. At Cartier, creative director Jeanne Toussaint's love of animals came shining through in a special commission from the Duke of Windsor, who brought her four simple Art Deco line bracelets with rubies, sapphires, and emeralds, as well as a necklace, with instructions that their gems be used in the jewel. Toussaint and designer Peter Lemarchand envisioned the bracelets as the tail feathers of a flamingo. Diamonds and platinum formed the rest of the body of the bird. A citrine and small marquise sapphire composed the beak. The Duke gave the brooch to the Duchess of Windsor in March 1940.

ABOVE LEFT The Duchess of Windsor wearing her Cartier Flamingo Brooch in a photo taken around 1940.

ABOVE RIGHT Page from a Cartier Paris special-order register showing the design and details of a flamingo brooch commissioned by the Duke of Windsor.

OPPOSITE Flamingo Brooch by Cartier Paris, 1940. Diamonds, emeralds, sapphires, rubies, citrine, platinum, and gold. Formerly in the collection of the Duchess of Windsor.

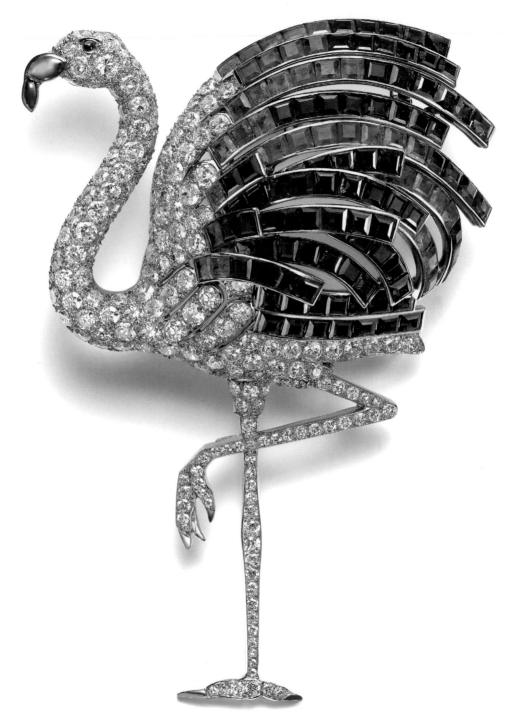

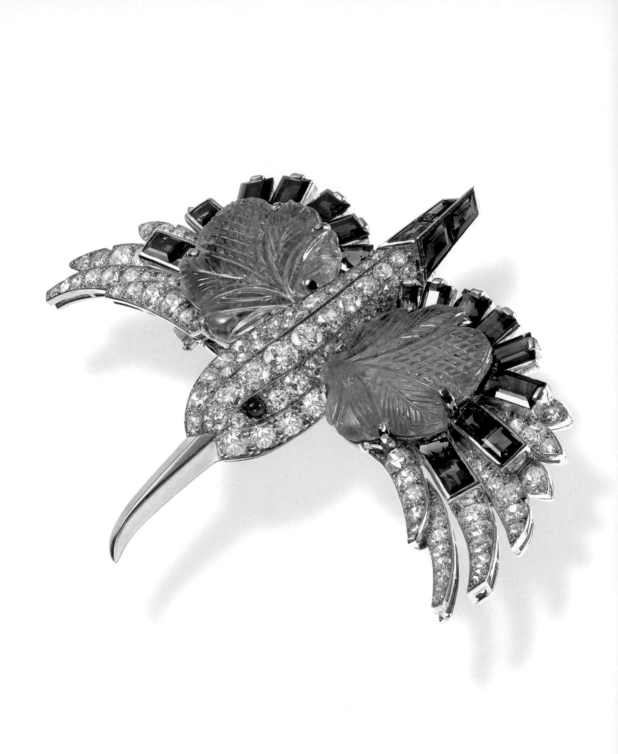

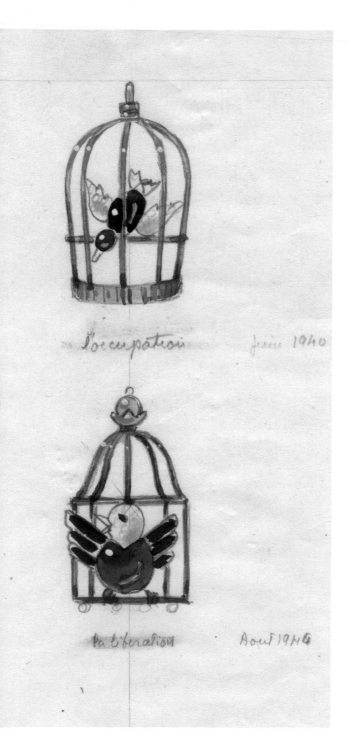

l'occupation juin 1940

la libération Aout 1944

WHEN THE GERMANS occupied Paris in June 1940, many jewelers in the City of Lights subtly supported the Resistance with bird motifs. In 1941, Cartier made an exceptional clip brooch of a kingfisher, a symbol of peace and prosperity. The bird, soaring in full flight, has a diamond head, gold beak, and outstretched wings set with diamonds; calibré-cut sapphires; and two carved leaf-shape emeralds totaling 17.66 carats.

OPPOSITE Kingfisher Clip Brooch by Cartier Paris, 1941. Diamonds, emeralds, sapphires, rubies (eyes), platinum, and gold.

LEFT A Cartier design of the Oiseau en Cage and Oiseau Libéré brooches made during and after World War II. The bird in a cage symbolized France occupied by enemy forces, and the freed bird brooch celebrated the liberation of Paris.

MELLERIO INGENIOUSLY worked around the wartime shortages of gems and metals by using blue plique-à-jour enamel on a bird brooch. It was unlike anything Mellerio had produced previously or that was being made at the time. The plique-à-jour enamel on the rounded body and fanciful tailfeathers made the piece far more sculptural than the majority of those created with the same style of enamel in the Art Nouveau era.

During the occupation, other Parisian jewelers made more obvious patriotic statements with bird jewels. René Boivin manufactured artistic eagle brooches as a symbol of the Resistance. In 1942, Van Cleef & Arpels created a large gold bird of paradise set with diamonds, rubies, and sapphires in the plumage. The gems were a reference to the blue, white, and red of the French flag.

While these nationalistic statements were overlooked by the Nazis, the small *Oiseau en Cage* Cartier brooch depicting a little bird in the colors of the French flag—sapphire, diamond, and coral—locked in a gold cage, got Jeanne Toussaint into trouble. She was questioned by the Gestapo, who felt the jewel they spotted in the firm's window display was provocative. It is believed that she placated the authorities by claiming the design was an old one dating back to the mid-1930s. After the war, Toussaint and designer Lemarchand reimagined the Cartier brooch as *Oiseau Libéré*, a bird singing in a cage with its door wide open (page 59).

OPPOSITE Bird Brooch by Mellerio, ca. 1940. Diamonds, ruby (eye), enamel, gold, and platinum.

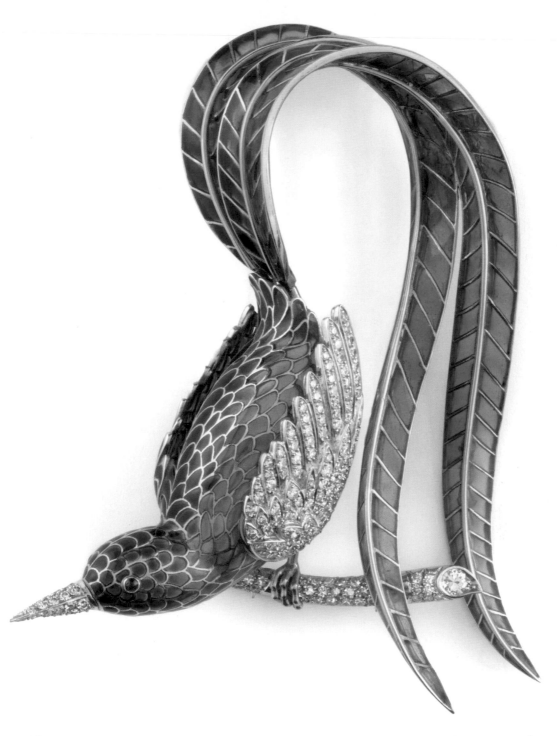

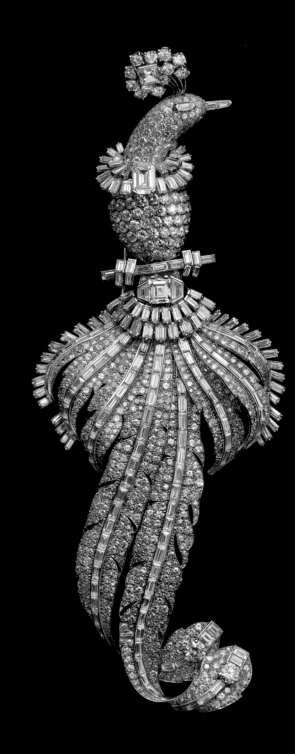

AT WAR'S END IN 1945, bird brooches in France continued to be emblems of freedom. They also signaled a return to glamour. Grand, artistic, and colorful, the birds were the perfect pieces to pair with the New Look collection conceived by Christian Dior in 1947, with its A-line skirts, cinched waists, and fitted jackets. The collection would set the fashion tone for the next decade.

In 1948 Cartier designed a gargantuan bird brooch made under the supervision of Jeanne Toussaint. The special-commission jewel measures almost eight inches high and weighs approximately 5.5 ounces. It has about 90 carats of diamonds in the platinum setting. The largest gems—an emerald-cut diamond weighing 2.76 carats and two square-shape diamonds weighing 2.35 and 1.29 carats—were provided by the client. Cartier supplied the rest of the 991 baguette, brilliant, and fancy-cut diamonds. The geometric gems were set vertically in lines around the neck, on the feet, at the base of the body, and in lines down the tail. The gentle S-form of the jewel gave the piece a sense of movement and lots of attitude. Shortly after it was completed, *Harper's Bazaar* published a photo of the bird pinned to the bodice of a black velvet strapless gown worn by a model. The caption identified it as "Madame Robert Lazard's diamond peacock."

OPPOSITE Bird Brooch by Cartier Paris, 1948. Diamonds, platinum, and white gold.

ABOVE A model wearing Cartier's diamond bird brooch clipped to a Robert Piguet dress. Photo by François Kollar for the November 1948 issue *Harper's Bazaar*.

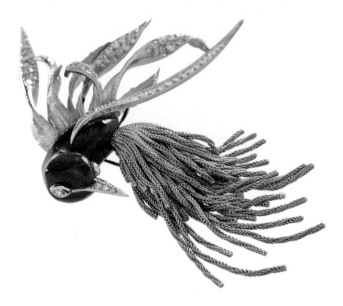

ONE OF THE BIGGEST flocks of bird brooches made in the postwar period flew out of Pierre Sterlé's studio. The master jeweler learned the craft at a very young age from his uncle and then established his own manufacturing business in 1934 at age 29. In the 1950s, he transformed his company into a design house and became known for abstract diamond jewels inspired by the concept of movement. The originality of the designs not only captured the attention of royal clients, but also made the designer a favorite of a small handful of couturiers. Jacques Fath showed Sterlé's jewels at his fashion presentations. Sterlé also worked with Pierre Balmain, Christian Dior, and Marcel Rochas.

While Sterlé's diamond jewels had a dynamic minimalist quality, his birds were expressive and layered with spectacular design details specific to certain species, including parrots, woodpeckers, swallows, and toucans. For the birds' bodies and beaks, Sterlé used a variety of specially cut or unusually shaped gems. Diamonds and platinum highlighted details such as the beaks and heads of swift brooches. Sterlé employed a couple of different types of goldwork on the feathers. Some birds had textured wings. Many had plumage composed of loop-in-loop chains (called *fil d'ange*). The goldwork was inspired by one of Cleopatra's bracelets, which Sterlé saw on a visit to the Museum of Cairo.

ABOVE Bird Brooch by Sterlé, ca. 1960. Labradorite, diamonds, gold, and platinum.

OPPOSITE, CLOCKWISE FROM TOP LEFT

Bird Brooch by Sterlé, ca. 1960. Pearls, tourmaline, diamonds, ruby (eye), and gold.

Exotic Bird Brooch by Sterlé, ca. 1960. Diamonds, emeralds, gold, and platinum.

Parrot Brooch by Sterlé, ca. 1960. Green sapphires, diamonds, gold, and platinum.

Swift Brooch by Sterlé, ca. 1963. Labradorite, diamonds, gold, and platinum.

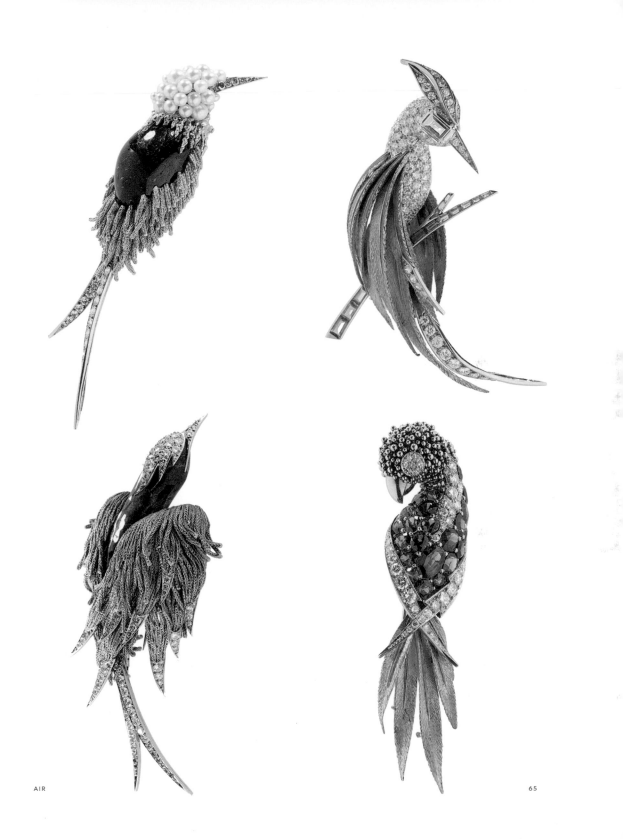

BOUCHERON PRODUCED a flock of colorful bird brooches in the late 1950s. The designs were based on actual birds such as the flycatcher (*gobe-mouche* in French) and the redstart. Boucheron, however, took artistic license with the neutral colors of the birds' plumage. The jewels are covered in semi-transparent guilloché red, green, and blue enamel accented with pavé-set diamonds. Underneath the enamel, the pattern of the birds' feathers, engraved into the gold, adds texture to the designs.

IN 1969 TIFFANY & CO. captured the essence of craft and macramé that was so popular in fashion at the time with this owl bracelet. The feathers on the side of the bracelet are sculpted in gold. Twisted gold "eyebrows" roll up and over the head. The expressive emerald and diamond eyes are surrounded by rays of gold.

OPPOSITE LEFT Redstart Clip by Boucheron, designed in 1956, made in 1988. Diamonds, emerald (eye), enamel, gold, and platinum.

OPPOSITE RIGHT Gobe-mouche Clip by Boucheron, designed in 1957, made in 1988. Diamonds, sapphire (eye), enamel, gold, and platinum.

BELOW Owl Bracelet by Tiffany & Co., 1969. Diamonds, emeralds, and gold.

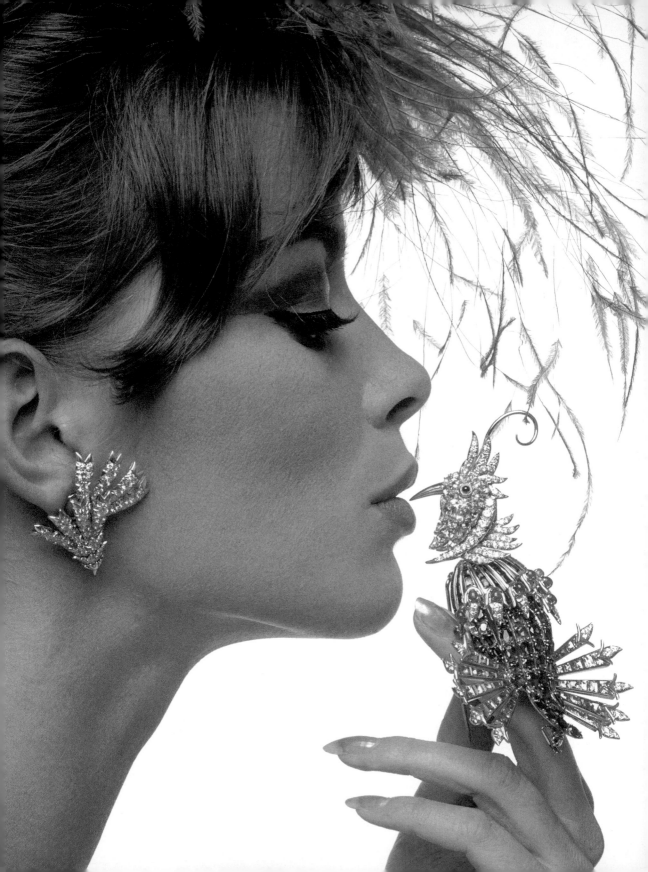

THE BIRD JEWELS made during the 1960s had a sense of wit and whimsy that defined so much of the creative jewelry of the era. The Bird on a Rock clip, conceived by the firm's French designer Jean Schlumberger in 1965, is the best-known example. The joyful jewel included a little diamond and gold bird with an exaggerated crest of feathers perched atop a large semiprecious stone. Bird on a Rock was Schlumberger's way of working within the trend for big stones, but at the same time adding a touch of playfulness.

The piece has been made any number of times over the years. In celebration of the designer's posthumous retrospective in 1995 at the Musée des Art Décoratifs in Paris, Tiffany & Co. placed the 128.54-carat Tiffany diamond, one of the world's largest fancy yellow diamonds, into a charming Bird on a Rock setting. The combination of the little bird with the historic diamond was such a crowd pleaser that Tiffany kept the stone in the Schlumberger jewel for a long time after the exhibition closed.

OPPOSITE A model wearing Jean Schlumberger for Tiffany & Co. diamond ribbon earrings and holding the designer's Oiseau de Paradis clip made of yellow beryls, rubies, diamonds, amethysts, emeralds, sapphires, and aquamarines. Photo by Bert Stern for the November 15, 1963, issue of *Vogue*.

ABOVE Bird on a Rock Brooch designed by Jean Schlumberger for Tiffany & Co. in 1965, made in 2019. Tanzanite, pink sapphire (eye), diamonds, platinum, and gold.

ABOVE Gray Parrot Brooch by Hemmerle, 1997. Colored diamonds, diamonds, gray moonstones, black star sapphires, rubies, and white gold.

THIS GIANT GRAY parrot brooch created by Hemmerle in 1997 was part of a new chapter in the history of the German firm. Established in Munich, Germany, in 1893, Hemmerle became a favorite in the city due to its classic designs and refined craftsmanship. Shortly after the 100th anniversary of Hemmerle, the third generation to run the

family business, Stefan Hemmerle and his wife, Sylveli, began making jewelry that reflected their personal interests and aesthetics yet maintained the firm's fine traditions of manufacturing. Most of the collection produced during this period was inspired by nature, executed in a neutral color palette, and made on a grand scale.

The gems in the nearly six-inch-tall bird brooch perfectly reconstruct the markings of a gray parrot. It is composed of 234 white and gray moonstones cut in the shapes of the feathers and beak. Black star sapphire feathers decorate the primary feathers on the upper part of the tail. Rubies infuse a pop of color on the tailfeathers. Gray diamonds, which were unusual in jewelry in the mid-1990s, are mixed with white and brown diamonds on the body and eye. The 13.56-carat diamond the parrot clutches with its feet is a beacon of brilliance.

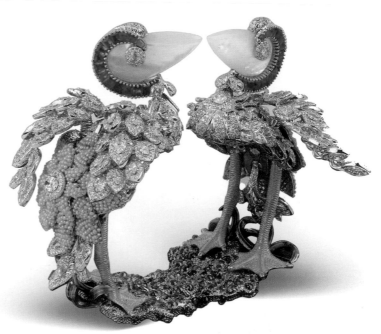

THE POETIC PELICAN cuff designed by Bina Goenka in 2009 reflects her inventive approach to high jewelry. Born in Mumbai, India, Goenka was educated as a lawyer. However, before she began to practice law, she dabbled in jewelry design and realized it was her passion. She established her label in 2007.

Goenka's unconventional designs often have elaborate backstories. The genesis for the pelican cuff started in London's Regent's Park, where Goenka would often see the birds. "I noticed that they were always in a pair and interacting with each other," explains Goenka. "One flies up, the other moves a little, when people walked by they'd turn to stare in unison." The designer echoed the bird's activities in her design. "As the hand moves in conversation with people, the pelicans come alive and also make their own movements," says Goenka.

The jewel includes fascinating details that add to the narrative. Pear-shape pieces of mother-of-pearl suggest the large beaks and throat pouches that can hold gallons of water. The feathers are marquise and round diamond segments that are set in a sculptural manner on top of *en tremblant* springs that enable movement. Little keshi pearls strung on wires in the pattern of a lotus flower form the bodies of the birds. The legs of the birds are ridged, and the feet are webbed. The birds are standing in brown diamonds representing mud. This interior element at the bottom of the bracelet is not really seen when the piece is worn but transforms the jewel into an object to admire when it is displayed.

ABOVE Pelican Cuff by Bina Goenka, 2009. Diamonds, colored diamonds, pearls, mother-of-pearl, emeralds, enamel, and gold.

WATER

fish

LOVE OF THE SEA, sports, and art have all inspired fish jewelry in the 20th century. A big bejeweled school, which began swimming around 1920 and remained in the style currents for decades, was created by American jewelers in response to burgeoning enthusiasm for fishing. Several presidents of the United States, including Herbert Hoover, Franklin D. Roosevelt, and Harry S. Truman, were fans of the sport. Writer Ernest Hemingway added to the allure with his passion for fishing in Cuba and Key West. Many celebrities enjoyed fishing on holidays, including Yankee slugger Babe Ruth and Hollywood stars Bette Davis, Ginger Rogers, and Clark Gable. Society anglers went on fishing expeditions and stayed in luxury camps in places like California, Florida, and further afield in Canada and South America.

•●•●•

Often a fish brooch was made as a memento of a specific trip. In 1927 one celebrated angler ordered a platinum and diamond Tiffany & Co. swordfish brooch to celebrate his historic catch. It is engraved on the back, "Commissioned by Oliver Cromwell Grinnell. Commemorates the catching of the first broadbill swordfish off of the Atlantic coast."

Many jewelers rendered sporting fish brooches in diamonds and platinum. Specially cut sapphires were often peg- or channel-set to fit into the fins or body of a creature. One tarpon brooch, made by J. E. Caldwell, has a gradation of dark to light sapphires along the back, adding subtle texture to the plate-like scales. Blue and black enamel highlighted fins on certain fish. Small parts, like the finlets on a tuna, were occasionally sculpted in gold. Enamel on certain sailfish has shading from blue to yellow and brown, suggesting the light of the sun reflecting off a fin.

PREVIOUS SPREAD
Dolphin Brooch, also known as The Night of the Iguana, designed by Jean Schlumberger for Tiffany & Co in 1964, made in ca. 2000. Diamonds, emeralds, sapphires (eyes), platinum, and gold.

OPPOSITE, CLOCKWISE FROM TOP LEFT
Bonefish Brooch, ca. 1920. Diamonds, spessartine garnet (eye), and platinum.

Sailfish Brooch, ca. 1920. Sapphires, diamonds, blue-green diamond (eye), and platinum.

Tarpon Brooch by J. E. Caldwell, ca. 1935. Sapphires, diamonds, emerald (eye), enamel, and platinum.

Sailfish Brooch, ca. 1920. Sapphires, diamonds, emerald (eye), and platinum.

Swordfish Brooch by Tiffany & Co., 1927. Diamonds, ruby (eye), and platinum. Commissioned by Oliver Cromwell Grinnell.

Tuna Brooch, ca. 1935. Diamonds, yellow diamond (eye), enamel, gold, and platinum.

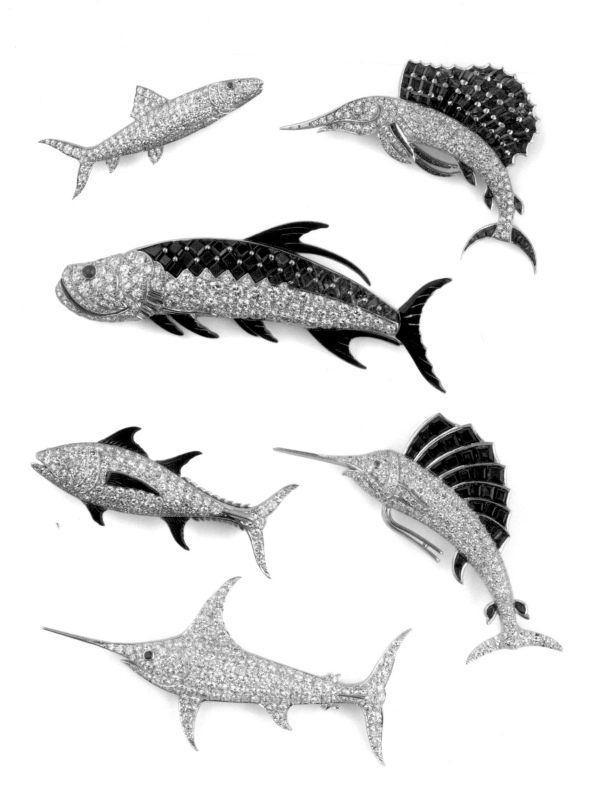

IN THE MID-20TH century, some jewelry designers, on a quest to make original work, looked to the Renaissance for inspiration. Jean Schlumberger was among them. The French designer felt out of sync with other jewelers. "It's very complicated," he told *Réalités* in 1957. "I make jewels, but I hate modern jewelry—and I can't tell people I make antique jewels." Modern jewelry for Schlumberger meant flamboyant diamonds, which he described as "mainly a display of cash value."

Born into a well-to-do family, Schlumberger had several design jobs before couturier Elsa Schiaparelli hired him to create costume jewelry in 1938. Flying fish earrings were among pieces that were credited "Schlumberger for Schiaparelli." After World War II, Schlumberger moved to New York City and opened a precious jewelry firm. One of his most beloved objects from this period was a gold lighter in the shape of a sardine. In 1956, Schlumberger became a byline designer for Tiffany & Co., where he drew inspiration for aquatic-themed jewels from illustrated books. He also studied the sea firsthand at his vacation home on Guadeloupe.

Elizabeth Taylor put a spotlight on a Schlumberger fish brooch and made it one of his most famous pieces. Richard Burton bought the brooch for Taylor to spark memories of the good times the couple shared in Puerto Vallarta when he was on location filming *The Night of the Iguana*. The jewel has diamond scales with sculptural gold netting and waving fins. A darting tongue, emerald lips, and cabochon sapphire eyes decorate the head. It is intended to be worn head down so that the eyes appear to look up.

Schlumberger called the brooch a "dolphin," a reference to dolphins found in art from the Renaissance period. Those creatures and Schlumberger's brooch don't resemble bottle-nosed dolphins; they are a fantasy rendition of fish. When Elizabeth Taylor acquired the jewel, the design became popularly known as the *Night of the Iguana* brooch.

OPPOSITE On December 2, 1964, at the Lido in Paris, Elizabeth Taylor wore the Night of the Iguana brooch in her hair, along with earrings by Bulgari and a gold one-shoulder gown by Balenciaga.

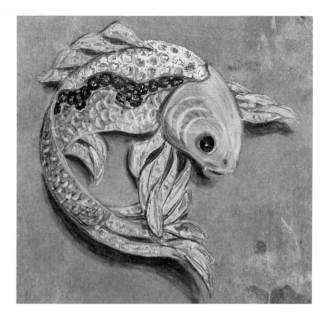

FULCO DI VERDURA shared with Schlumberger a similar artistic attitude toward traditional jewelry. The designer delivered wickedly funny commentary about large gems—he called a huge solitaire diamond ring "a swimming pool" and dismissed a necklace with a gigantic sapphire as "mineralogy not jewelry." His dishy remarks and privileged background made him a full-fledged member of café society.

A duke born in Palermo in 1899, Verdura went to work for Coco Chanel in Paris around 1926. The two traveled together to see the Renaissance jewelry at the Treasury of the Munich Residence in Germany and the Byzantine mosaics in the Basilica of San Vitale in Ravenna, Italy. These destinations were a source of inspiration for Verdura as he redesigned Chanel's personal collection of jewelry and made her iconic Maltese cross cuffs. The historical sites they visited and the jewels he saw remained touchstones for Verdura throughout his career.

After working at Paul Flato in New York and Los Angeles for a few years, Verdura opened a boutique in New York City in 1939. The menagerie in Verdura's collection included a series of gem-set fish that were a tribute to Renaissance dolphins, or fantasy fish (page 11).

Verdura painted miniatures as a hobby, and he also illustrated each of his jewels in artistic ink and gouache. A fish brooch Verdura made in 1966 captures the painterly quality of his original designs. Yellow enamel in a scale pattern covers the fish's body, which is in motion with gently curling fins and a veiled tail. Light green enamel accents the diamond fins. Sapphires add contrasting color to the back. A ruby forms the eye. The jewel was purchased by the Italian industrialist Gianni Agnelli as a Christmas present for his wife, Marella.

OPPOSITE Fish Brooch by Verdura, 1966. Diamonds, sapphires, ruby (eye), enamel, gold, and platinum. Formerly in the collection of Marella Agnelli.

ABOVE Ink and gouache drawing of Verdura's Fish Brooch, 1966.

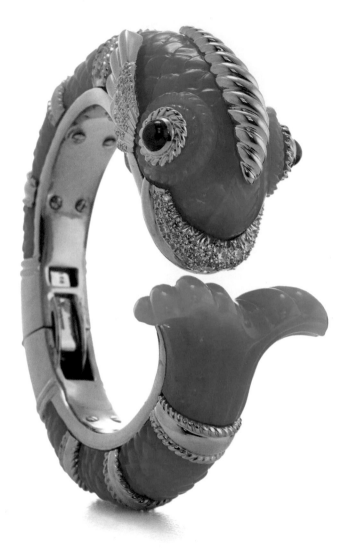

AMERICAN JEWELRY designer David Webb came from a very different background than Schlumberger and Verdura, but his philosophy about modern jewelry and his love of animals in design were essentially the same. In the 1960s, he told columnist Ruth Preston, "What's wanted is the effect of tremendous glamour, not of tremendous value; a soft look rather than a stiff hardness of big stones just sitting around."

The designer's first experience with metalwork was in the 1930s when, as a nine year old, he took a crafts course at a WPA school near his home in Asheville, North Carolina. He also picked up the skills of goldsmithing and gem-setting from his uncle, a craftsman. At seventeen, Webb left home to apprentice in New York, often switching jobs to learn as much as he could from various workshops. After serving in the army during World War II, he started his own business in 1948. He had great success with his initial collections,

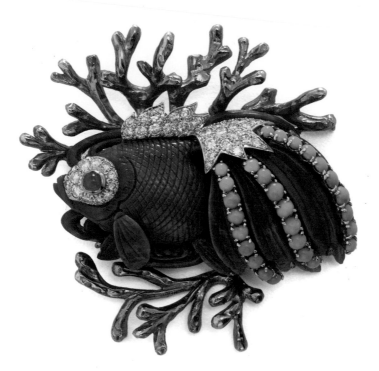

which showcased traditional mid-century work. What put him on top was his artistic breakthrough with animal jewels.

Many of Webb's fish are made of carved gemstones and embody the spirit of Renaissance motifs. Some of the carvings came from antique jewels. In 1966, for example, Webb took a vintage carved coral fish with scales engraved on the body and lines on the veiled tail and embellished it with turquoise. Diamonds accent the top and encircle the emerald eye. Gold forms a coral reef behind the creature. The jewel originally belonged to actress Dina Merrill, who was the daughter of the great jewelry collector Marjorie Merriweather Post.

The same spirit of the Renaissance is found in a chrysoprase fish bracelet David Webb originally designed in 1975; it looks as though it could have accented a fountain or building in the heart of Rome. To manufacture the jewel, pieces of chrysoprase were carved with fish scales and pieced together in sections with gold bands connecting them. The head has cabochon sapphire eyes and diamonds accenting a smile.

OPPOSITE Fish Bracelet by David Webb, designed in 1975, made in 2017. Chrysoprase, sapphires (eyes), diamonds, gold, and platinum.

ABOVE Fish Brooch by David Webb, 1966. Coral, turquoise, emerald (eye), diamonds, gold, and platinum. Formerly in the collection of Dina Merrill.

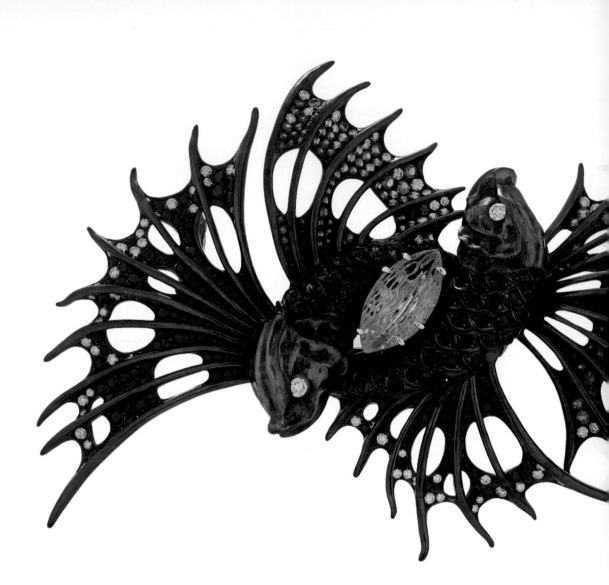

ABOVE The Waltz of Fighting Fish Brooch by Stephen Webster, 2019. Santa Maria aquamarine, black spinels, black sapphires, blue sapphires, diamonds, and titanium.

IN THE LATE 1980S, English jewelry designer Stephen Webster made fish jewels in reaction to the standard animal designs he saw on the market. "There were lots of things like lions' heads and butterflies," explains Webster. "I didn't want to make a butterfly, but the shape of the animal made me think of a flying fish brooch."

Since the beginning of his career, the designer has sought to go against the tide. Born in Gravesend, an ancient town in northwest Kent, England, Webster began his technical jewelry training at

the age of sixteen at the Medway College of Design and went on to work for several jewelers before he launched his own collection in 1989. His work has always been defined by a wide vocabulary of English and historical references infused with a rock 'n' roll edge.

In 2009 Webster debuted Jewels Verne, a tribute to the sea adventures in the novels of 19th-century author Jules Verne. Among the most extravagant jewels in the collection are Japanese fighting fish bracelets and brooches. The genesis for the idea of depicting the fierce fish came during an early-morning excursion to a fish market in Tokyo with R.E.M. frontman Michael Stipe. "You don't find Japanese fighting fish in the fish market, but you realize why there is sushi," explains Webster. "The repertoire of what they eat out of the sea is amazing."

In order to make his fighting fish a special shade of electric blue and on a large sculptural scale, Webster rendered the jewels in titanium, a metal that is lightweight and can take on various colors through an anodization process. While it may not be considered precious, titanium requires a master craftsman's touch. "Gold does everything you want it to do. You can stretch it to thin wire and beat it and liquify it," says Webster. "Titanium barely does anything. It can be processed with 3D printing, but we used much older techniques." Through trial and error, the designer and his workshop figured out how to liquify small amounts of titanium for the larger jewel.

The blue metal was enhanced with a gradation of light- to dark-blue sapphires and a few diamond highlights. At the center of the brooch is a marquise-shape Santa Maria aquamarine, carved on the reverse to look like the turbulent waters between the creatures.

Webster continues to add fish to his collections, though for different reasons. "I feel lucky to live in England and have a home on the edge of the White Cliffs of Dover, because the sea is like lifeblood to me," says Webster. "Today we are destroying our oceans, so I do what I can to draw attention to the importance of marine life. The main charities my company is involved with—Plastic Oceans Foundation and Waterkeeper Alliance—relate to ocean preservation."

lion's paw scallops

MOLLUSK SHELLS have been collected by beachcombers and worn casually in jewels since ancient times. They have also been recreated in gold jewelry for hundreds of years. But throughout history, no one has combined real seashells with gems and gold quite as magnificently as the designer Fulco di Verdura. The remarkable shell jewels Verdura launched around 1941 reflected his passion for Renaissance style and showed off the designer's sense of whimsy.

· • · • · •

VERDURA'S EARLY shell collections included gem-set turbo shell earrings and a harp shell brooch, but the most coveted items by far were his lion's paw shell brooches. Knuckle-like sections of the shell, which loosely resembles the paw of a lion, are interspersed with wavy tendrils of gold usually set with diamonds and sapphires or turquoise. The precious parts were intended to look like waves receding from the surface.

In a 1941 interview with the *New Yorker*, Verdura revealed that he bought his shells from the gift shop at the American Museum of Natural History and added a bit of

saucy banter about selling them: "What I get a kick out of is to buy a shell for five dollars, use half of it, and sell it for twenty-five hundred," said the duke. He never publicly explained how difficult (and expensive) it was to set the shells with gems and gold.

Upon occasion, the Verdura jewelry firm still makes shell brooches, working with descendants of some of the original craftsmen. The process involves finding pristine vintage shells with the same character as the original shells that were available in the 1940s. (Contemporary lion's paw scallop shells do not display the same knobbiness due to climate change affecting the ocean.)

The first step is to clean and shine the lion's paw on a polishing wheel, which has to be done very carefully in order not to damage the delicate shell. Next, tendrils are shaped by hand in green wax, which is then replaced by gold using the lost-wax casting process. "What Verdura did

OPPOSITE Lion's Paw Shell Brooch by Verdura, 1942. Natural scallop shell, sapphires, diamonds, and gold. Commissioned by Alberico Boncompagni Ludovisi, prince of Venosa.

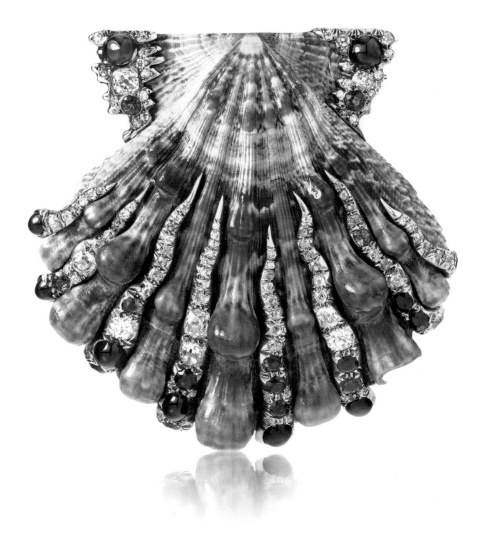

so brilliantly was to follow the linear
channels in the shell and maintain
a sort or drippiness of water in
the way the gold was shaped,"
explains Nico Landrigan, president
of Verdura. The stones are then set
within the tendrils.

Measuring the piece and
deciding where to drill the shell

to place the gold- and gem-set
tendrils is one of the final steps.
"There are parts of the shell at the
very lip that are extremely thin,
and it could all break easily if the
drilling of the holes is done wrong,"
says Landrigan. "The bench jeweler
has to work fast and very carefully
when they make the drill holes."

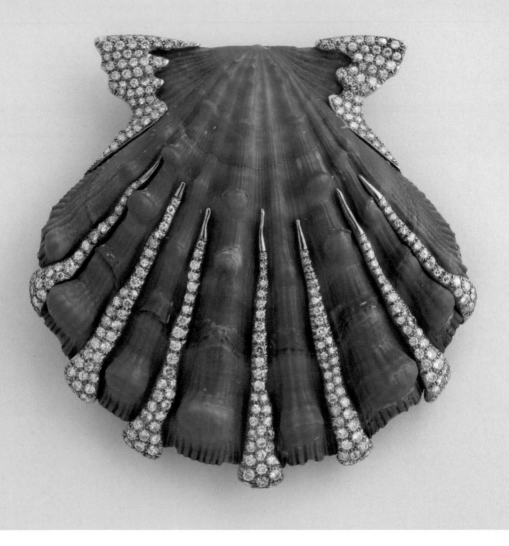

Each of Verdura's lion's paw brooches are one-of-kind. Their uniqueness has attracted some of the world's most discerning jewelry collectors, including Standard Oil heiress Millicent Rogers, Mona Bismarck, Betsey Whitney, and Tallulah Bankhead.

ABOVE Lion's Paw Shell Brooch by Verdura, ca. 1940. Natural scallop shell, diamonds, and gold. Formerly in the collection of Millicent Rogers.

OPPOSITE Actress Paulette Goddard wearing a Verdura lion's paw brooch pinned to a scarf she sports with a Hattie Carnegie cabana suit. Photo by Horst P. Horst for the January 15, 1941, issue of *Vogue*.

Études d'après nature.

starfish

STARFISH HAVE captured the imagination of some of the most creative jewelers of the 20th century. René Boivin, Elsa Peretti, Hemmerle, and the Surrealist artist Salvador Dalí have all made starfish jewels. Dalí was undoubtedly interested in the symbolism of the starfish, which represents renewal due to its ability to regenerate lost appendages. Most designers, however, appreciate the endless summer days on a beach that this expressive creature suggests.

·•·•·•·

ONE OF THE MOST iconic starfish designs was created in 1937 under the direction of Jeanne Boivin of the French jewelry firm René Boivin. At a time when few women worked in the jewelry industry and even fewer were decision makers, Madame Boivin presided over the company after her husband, René, died in 1917. Like many chief executives in jewelry whose name is the brand, Madame Boivin did not draw. Instead, she hired designers

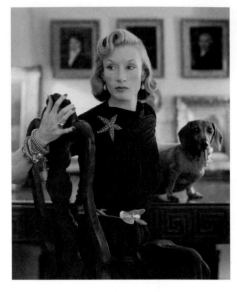

to carry out her vision. Juliette Moutard, who worked at Boivin from 1934 to 1970, conceived many animals during her tenure, including the starfish.

Madame Boivin felt precious gems should be used artistically, not ostentatiously. One way she had Moutard and her craftsmen carry out this concept was with colorful pavé settings of semiprecious stones. Pavé-set amethysts and 71 cabochon rubies cover the curved surface of this starfish. Each of the five arms was made in several small parts so that the limbs are fully articulated. Gold tips at the ends of two arms naturalistically curl over.

ABOVE Millicent Rogers wearing her starfish brooch by René Boivin, among other jewels, with one of her dachshunds by her side. Photo by John Rawlings, 1939.

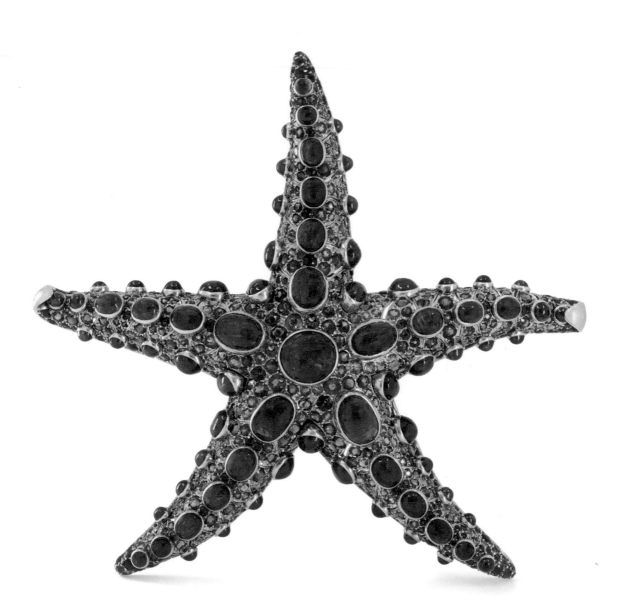

It is believed that only four amethyst and ruby Boivin starfishes were made in the 1930s. The first one was acquired by Oscar-winning actress Claudette Colbert; it became part of the permanent collection of the Museum of Fine Arts, Boston, in 2019. Millicent Rogers also owned a Boivin starfish brooch.

ABOVE Starfish Brooch designed by Juliette Moutard for René Boivin, 1937. Amethysts, rubies, and gold.

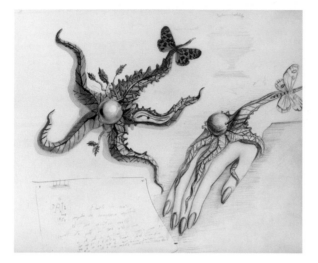

ABOVE Drawing of
Étoile de Mer Brooch
by Salvador Dalí,
ca. 1950.

OPPOSITE Étoile
de Mer Brooch by
Salvador Dalí, ca.
1950. Pearl, rubies,
diamonds, emeralds,
gold, and platinum
(starfish); emeralds,
sapphires, colored
diamonds, gold, and
platinum (butterflies).
Formerly in the
collection of Rebekah
Harkness.

ARTIST SALVADOR DALÍ added a starfish to his Surrealist collection of jewels in the late 1950s. The creature fit in perfectly with the Dalían symbolism involving nature, mythology, and religion that he started applying to jewels around 1938. In 1941, Dalí collaborated with Duke Fulco di Verdura on a collection that included an Apollo and Daphne brooch with a gold Palladian door accented with a turquoise- and ruby-studded pediment framing a Dalí drawing of the Greek god. The Dalí-Verdura jewels were exhibited at the Museum of Modern Art in New York with a presentation of Dalí and Miró paintings.

In 1949 Dalí signed a contract with New York–based jewelry manufacturer Carlos Alemany to create his own collections. "My jewels are a protest against emphasis on cost of the materials of jewelry," Dalí once explained. "My object is to show the jeweler's art in true perspective—where the design and craftsmanship are to be valued above the material worth of the gems, as in Renaissance times."

Many of Dalí's jewels did indeed make clever artistic use of materials. His most well-known jewel, the Ruby Lips brooch, had white pearls for teeth. The diamond and platinum Eye of Time brooch was set with a diamond teardrop pendant, a ruby at the lacrimal sac, and a watch dial painted by Dalí.

One of Dalí's most important jewelry clients, philanthropist Rebekah Harkness, owned some of his most rarefied jewels, including the Étoile de Mer brooch. Each of the long, fully flexible arms of the starfish is divided by a line of gold with diamonds on one side and rubies on the other. A large pearl forms the center of the piece. Gold branches with emerald leaves sprout from opposite sides of the starfish. The fantasy creature is made more surreal by a pair of gem-set butterflies that could be attached to the arms.

Harkness, one of the great patrons of the ballet in New York City in the 1960s, was photographed

wearing the starfish on several occasions. She often draped it over her shoulder with the arms hanging down her front and back. Once she highlighted the jewel's design to shocking effect when she appeared at a formal affair in full evening dress with the starfish clinging to her breast.

The creative ways Harkness wore the piece were completely in line with Dalí's ideas about how jewelry should be enjoyed. For a catalogue titled *Dalí: A Study of His Art-in-Jewels*, published in 1954, he wrote, "The jeweled pieces you find in this book were not conceived to rest soullessly in steel vaults. They were created to please the eye, uplift the spirit, stir the imagination, express convictions."

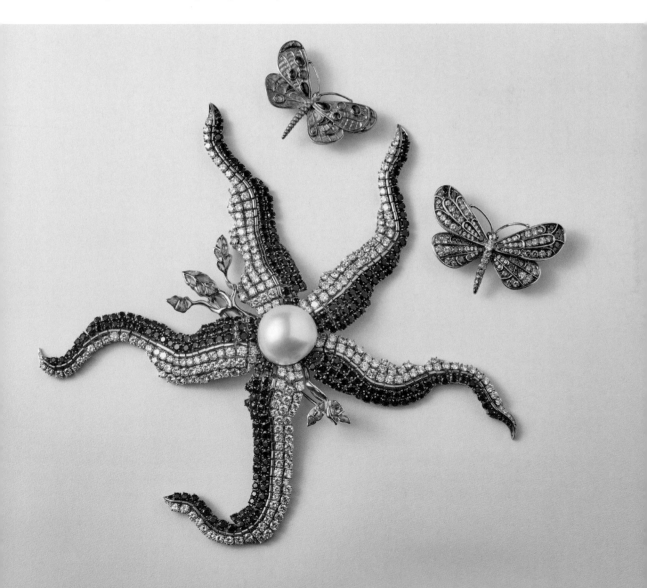

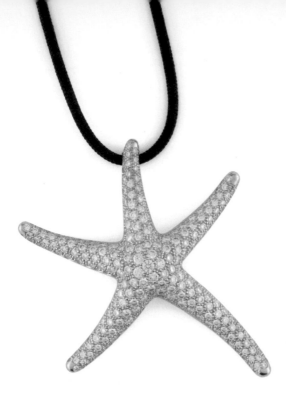

ABOVE Starfish Pendant designed by Elsa Peretti for Tiffany & Co. in 1985, made in 2012. Diamonds, platinum, and silk cord.

"MY RELATIONSHIP with the sea is total," Elsa Peretti explained in the 1990 exhibition catalogue *Elsa Peretti: Fifteen of My Fifty with Tiffany*. "As a little girl, I hunted for beautiful shells on the beach. In my times, beaches were more generous, no plastic, just polished glass and small shells." These memories resulted in the designer's starfish pendant, and, like everything in her collection, the jewel reflects her life story.

Brought up in Florence, Italy, Peretti moved to New York City in search of a creative life. While she worked as a model, she began making jewelry that fashion designer Halston, a friend of hers, then showed on the runway. Peretti got her big break when she was introduced to the executives at Tiffany & Co., who made her a byline designer in 1974.

Peretti's jewelry put Tiffany in touch with what was happening on the street. The chic pieces were sold at much lower prices than most jewels the firm offered and were therefore accessible to a wider audience. Yet they were also a hit with the group known as the Ultrasuaves, trendsetting women who wore Halston Ultrasuede.

Peretti's starfish pendants, which are casually strung on black silk cord, have a rounded surface and arms that extend in all directions. The designer's starfish are made in silver or gold. There are also fully pavé-set diamond and platinum styles that shine as brightly as the designer's vivid childhood memories of the sea.

THE DESIGN OF the starfish brooch made by Hemmerle in 1994 has experimental elements that would later become hallmarks of the German jeweler's iconoclastic style. Stefan Hemmerle and his wife, Sylveli, the third generation to run the family business, decided their new work would be in a palette of earth tones. For the starfish, they plated gold with copper, a far less valuable metal, in order to achieve the color they wanted. (In later years, Hemmerle developed manufacturing methods to produce fine quality jewels entirely of copper.)

Additional sparkle was added to the starfish's arms with nearly 48 carats of diamonds. In spite of the fact that brown diamonds, or anything in that section of the color wheel, were not universally admired in the mid-1990s, Hemmerle set an 8.73-carat natural fancy brown-yellow diamond, chosen to match the copper, at the center of the starfish. The Hemmerles recognized that among the 4Cs by which a diamond is judged—color, cut, clarity, and carat weight—color is a value judgment.

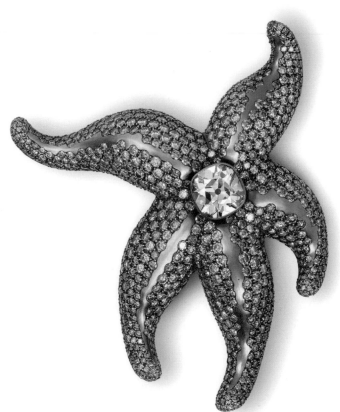

The clarity and cut of the starfish's center stone were highly graded.

The inspiration behind the starfish came from family vacations to the island of Sardinia. "The water world was always very attractive to my father," explains Christian Hemmerle, who joined the family business in 2006 to run it with his parents and his wife, Yasmin. "Starfish are among the most gracious and emotional animals of the sea."

ABOVE Starfish Brooch by Hemmerle, 1994. Brown-yellow diamond, diamonds, and copper-plated yellow gold.

seahorses

THERE IS AN undeniable charm about the delicate seahorse, which swims through the ocean, its body upright and tail wrapped in a curlicue. Seahorses symbolize many appealing qualities— patience, protection, good luck, and friendliness. Yet they are relatively rare in jewelry. The complexities of their sculptural bodies are most likely the deterrent. Nevertheless, some intrepid designers have taken on the design challenge with delightful results.

·•·•·•·

IN THE MID-1960S, a period when animals in jewelry were the height of fashion, Tiffany & Co. created several seahorses. For one bangle bracelet, the seahorse body was sculpted and engraved and wrapped around the silhouette of the jewel. The head and curled tail rise above the top. There is both a realism and a fantastical allure to the design.

ABOVE Princess Anne wearing a gold seahorse brooch at an event in Hyde Park, May 30, 1979.

OPPOSITE Seahorse Bracelet by Tiffany & Co., ca. 1970. Gold and turquoise.

OPPOSITE Virius
Pendant designed
by Guy Bedarida for
Marina B, 2018. Pink
spinels, citrines,
diamonds, and gold.

IN 2018 GUY BEDARIDA, the creative director at Marina B, designed a vibrant seahorse brooch as part of a 40th anniversary tribute to the animal jewels Marina Bulgari produced shortly after she launched her label in 1978. A member of the famous Bulgari jewelry family, Marina B chose the shortened moniker as a sign of her independence. Throughout her career, her bold collections were mainly defined by large specially cut gems in strong silhouettes and animal-themed jewels, including birds, turtles, and fish.

However, the designer herself never made a seahorse. It was Bedarida who came up with the idea in a bid to capture Bulgari's passion for the Mediterranean. Bulgari spent many summers vacationing at destinations along the Italian coastline as a child, as did Bedarida, who is French and was born in Italy.

Bedarida's design for the seahorse brooch is formed out of specially cut buff-top pink spinels and citrines that are set in a V-shape pattern on the body. Gold divides the gem patterns. Diamonds highlight the head and curled tail.

Mare nostrum, the ancient Roman term for the Mediterranean Sea, is the name Bedarida gave to the 40th anniversary collection. Each jewel was given a Latin name— the seahorse was dubbed Virius.

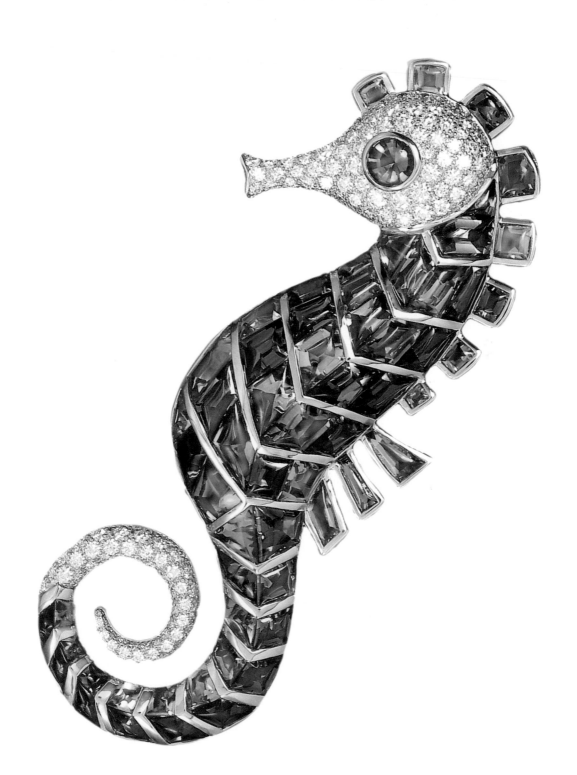

crocodiles

THE MEXICAN ACTRESS María Félix was famous for her love of animal jewelry. She had a vast collection of 19th-century snakes and a couple of very special Cartier serpents. In 1975, Félix commissioned Cartier to make an amazing necklace consisting of two crocodiles. The piece is exceptional in its design, and it is one of the very few important crocodile jewels ever created.

·•·•·•·

ACCORDING TO LEGEND, around 1975 María Félix waltzed into the Cartier boutique on the Rue de la Paix in Paris with live baby crocodiles to discuss the possibility of creating a jewel based on the little beasts. Félix brought in the live subjects as inspiration for the designers and to let them know she took the concept seriously.

Cartier sculpted the two crocodiles that make up the necklace from their snouts to the tips of their tails. The scutes on

the crocodiles' skin are one of the most remarkable elements, as they are raised off the surface just like on living crocodiles. Two different gems light up the yellow-gold crocs. One is covered in 1,023 fancy intense yellow diamonds totaling 60.02 carats. The other has 1,060 emeralds totaling 66.86 carats. Both crocodiles are entirely articulated with interior armatures similar to that of Félix's famed Cartier snake necklace (page 121). They can be separated and worn individually as brooches.

When the jewel was completed, Félix was so delighted she offered a Champagne toast to the craftsmen who had worked on the bold yet refined design. While the reptile never became a steady part of Cartier's collections, the firm has produced jewels with crocodile motifs over the years. In 2019 it made an impressive emerald and diamond necklace with one crocodile as a tribute to María Félix's historic jewel.

OPPOSITE Crocodile Necklace by Cartier Paris, 1975. Yellow diamonds, emeralds, rubies (eyes), and gold. Formerly in the collection of María Félix.

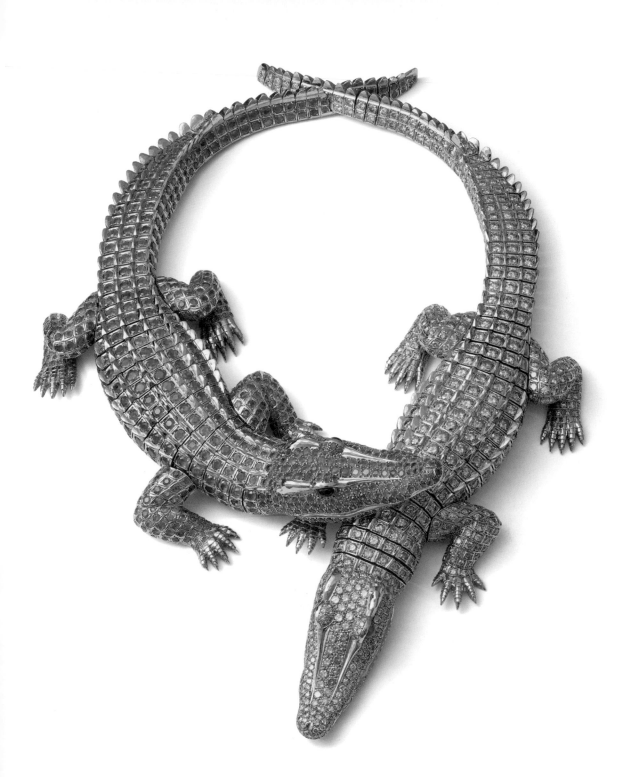

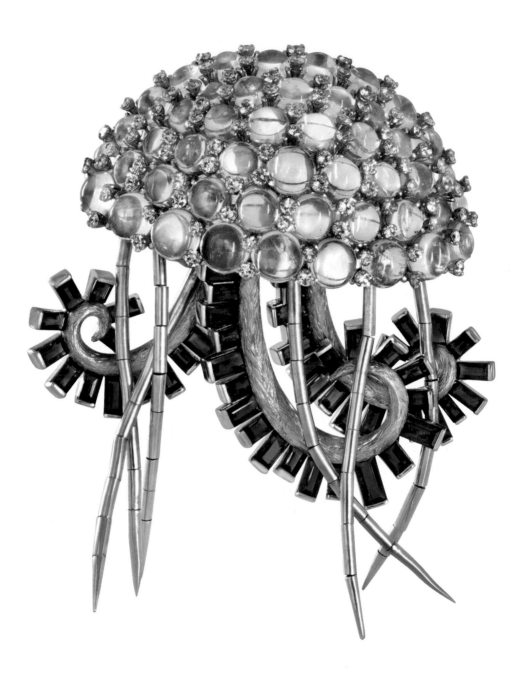

TWO OF THE MOST unexpected sea creatures transformed into jewelry are a jellyfish and a Portuguese man o' war. While similar to the jellyfish in appearance, a Portuguese man o' war is actually a siphonophore, meaning it is a compound creature made up of many organisms working together in a symbiotic relationship. Both creatures have inspired designers for personal and unique reasons.

· • · • ·

TIFFANY & CO. designer Jean Schlumberger created this jellyfish brooch after he heard about a run-in with the creature. His client and dear friend Bunny Mellon was stung by a jellyfish while swimming at the Mill Reef Club in Antigua in 1967. The horrible experience left her covered with lacerations on her shoulder and back. When Mellon relayed the story to Schlumberger during one of their regular phone calls, he decided to design the jewel as a surprise to help ease her pain. Mellon absolutely loved the piece when she saw it about six months after the accident.

The bell-shaped top is covered in moonstones, a gem with subtle iridescence that echoes the bioluminescence of some jellyfish. Diamonds are interspersed among the moonstones. The curled oral arms—where the stinging cells are located on an actual jellyfish—are made of chased gold and lined with various sizes of baguette-cut sapphires. A spring inside each of the six-inch-long gold tentacles allows them to move as though through water.

Schlumberger's jellyfish brooch is considered one of his most artistic masterworks. It's the kind of jewel that inspired the legendary fashion editor Diana Vreeland to describe his work as "not at all subtle. It takes over when a woman wears it. It's exciting. A Schlumberger lights up the whole room!"

OPPOSITE La Méduse Brooch designed by Jean Schlumberger for Tiffany & Co. in 1967, made ca. 2000. Moonstones, diamonds, sapphires, gold, and platinum.

WHEN DESIGNER Paula Crevoshay locked eyes on a naturally formed nearly 33-carat water opal from Mexico at a gem show in Tucson, Arizona, she knew immediately that it was the right stone to serve as a centerpiece for a Portuguese man o' war. Trained as an artist and anthropologist, Crevoshay lived for several years in India, where she gained a deep appreciation for animals and started dabbling in jewelry design. By the mid-1980s, she had made jewelry her full-time career. Eventually she relocated to Albuquerque, New Mexico, where she could be even closer to the nature that has inspired so many of her one-of-a-kind pieces. Crevoshay has earned acclaim for the unique gemstones she chooses, and many of her jewels have been exhibited in art and natural history museums.

For this Portuguese man o' war, Crevoshay surrounded the Mexican water opal with a variety of gems.

The carnelian was hand carved by Glenn Lehrer in the shape of the valves that draw in the oxygen to help keep the organism alive. Botryoidal chrysocolla represents a gland. Coral cabochons and pink sapphires accent the piece. Cobalt blue enamel covers some of the white-gold tentacles. "I always tell people that I do translation jewelry," explains Crevoshay. "It is a delight for me to translate from the floral and animal kingdoms into the mineral kingdom."

LEFT Portuguese
Man O' War Brooch
by Paula Crevoshay,
2014. Opal, carnelian,
chrysocolla, pink
sapphire, coral, white
gold, and blue enamel.

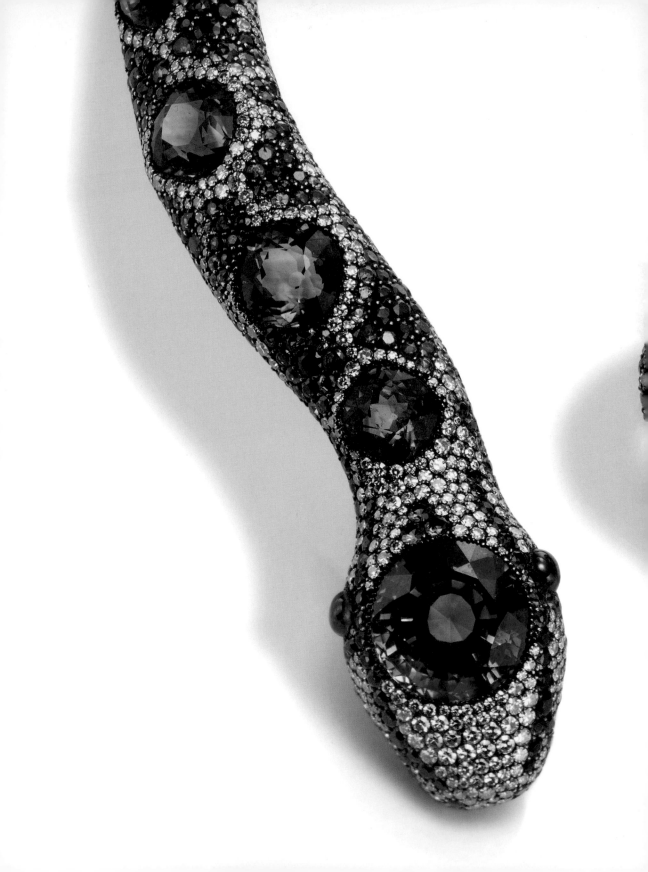

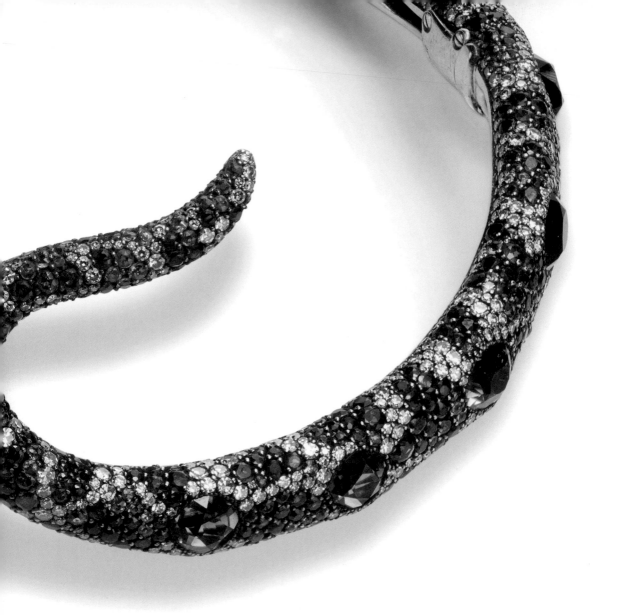

LAND

snakes

WHEN PRINCE ALBERT presented a gold snake engagement ring to Britain's young Queen Victoria in 1839, it sent a message to the world that the creature was a symbol of everlasting love. It also sparked a passion for snake jewelry. Queen Victoria's daughter-in-law, Alexandra, who was rarely seen without her snake bracelet, and France's Empress Eugénie, who owned a stunning Mellerio snake bracelet, added to the creature's allure in the late 19th century. Movie stars Elizabeth Taylor and María Félix and *Vogue* editor-in-chief Diana Vreeland flaunted snake jewels, which helped keep the desire for serpent styles high throughout the mid-20th century. In between these periods of peak popularity, snakes continued to slither through jewelry.

The fully flexible, linear bodies of serpents are ideal for wrapping around wrists, necks, fingers, and hands in bejeweled creations. The meandering form provides a visual sense of movement—a quality that has helped snake-themed jewels stand out from traditional silhouettes. Snake jewels were far more sinuous, for example, than the tiaras and elaborate bodice brooches worn during the Victorian age.

PREVIOUS SPREAD Serpent Choker by JAR (page 125).

OPPOSITE Snake Bracelet, French, ca. 1850. Emeralds, diamonds, pink sapphires (eyes), silver, and gold.

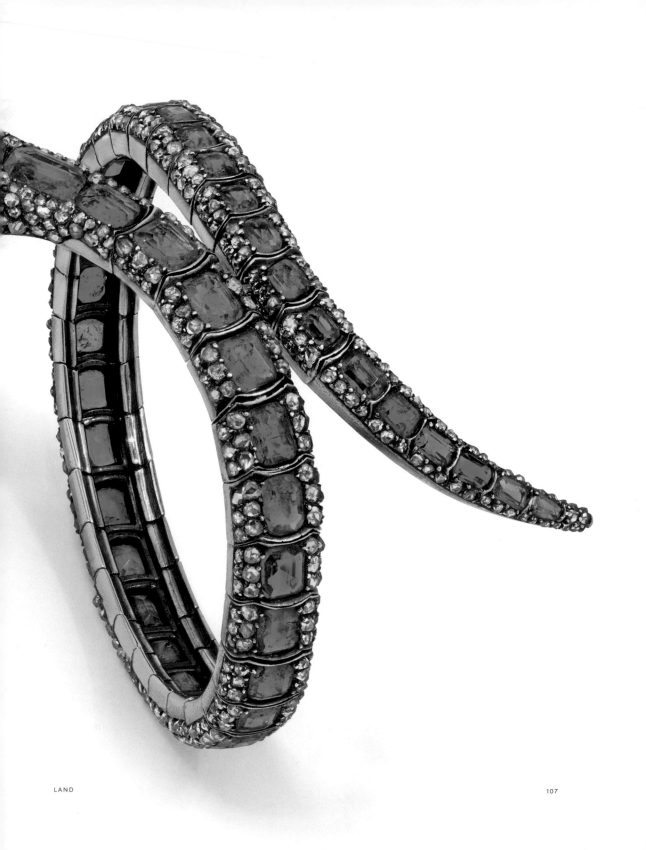

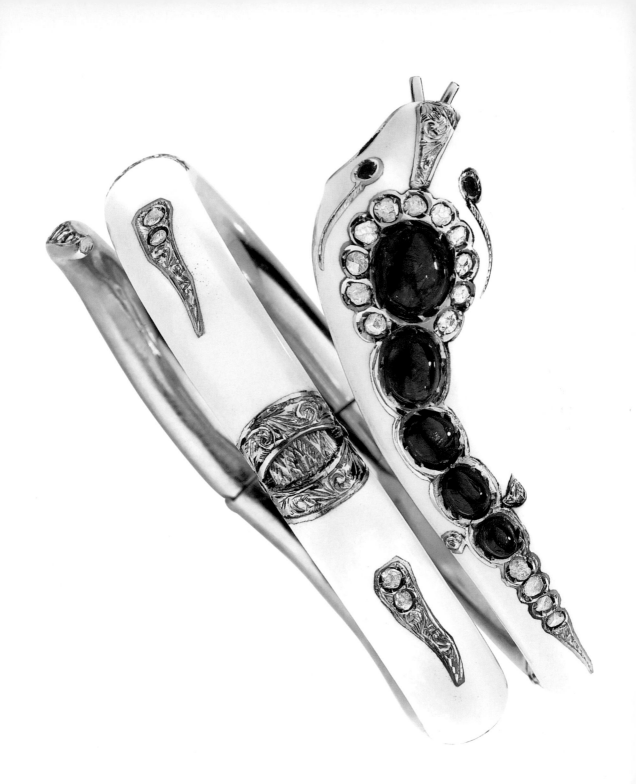

IN THE 19TH CENTURY, snake jewels were linked to ancient eras. Archeological digs in Pompeii, Troy, and other historical sites were constantly in the press and triggered a neoclassical revival and renewed interest in classical art and mythology. The goddess of love, Aphrodite, was one of many Greek deities who were depicted wearing snake jewels. Her bracelet represented seductive beauty. The Ouroboros—the motif of a snake forming a circle or figure eight with its tail in its mouth—was described by the ancient philosopher Plato as a symbol of everlasting life and was featured on many jewels. The power and wisdom of snakes was part of the lore of Alexander the Great and the first emperor of the Roman Empire, Augustus, both of whom were allegedly sired by divine serpents. According to Charlotte Gere and Judy Rudoe, authors of *Jewellery in the Age of Queen Victoria,* the wisdom of serpents was what Victoria wanted to convey in 1837 when she wore a bracelet with three intertwined snakes to the first official council that took place after her accession to the throne.

The desire for snake jewels intensified with the opening of the Suez Canal in Egypt in 1869 and renewed interest in Cleopatra. Countless paintings depicted the pharaoh wearing snake bracelets and a cobra headpiece. Melodramatic works of art showed Cleopatra's alleged suicide by snakebite after she learned of her lover Marc Antony's death.

Bracelets covered in precious and semiprecious stones were one of the most prominent styles in serpent jewelry in the late 19th century. Empress Eugénie's snake bracelet from French jeweler Mellerio was composed of rose-cut diamonds and turquoise. Great Britain's Princess Alexandra (who became queen consort when her husband Edward VII ascended the throne in 1901) often wore a gold serpent bracelet with a gem-set head.

Enamel and gold snake bracelets displayed a variety of enameling techniques, including matte opaque enamel and semi-transparent guilloché enamel, where a pattern is visible on the gold underneath the enamel. Mellerio created opaque enamel snake bracelets that were equipped with hinges so they could be unfurled and easily slipped on and off.

OPPOSITE Snake Bracelet by Mellerio, ca. 1860. Rubies, diamonds, enamel, and gold.

SLIGHTLY SINISTER snakes were a prevalent theme in the jewelry of the Art Nouveau movement, but they were relatively rare in the formal platinum and diamond jewelry made from 1900 to 1920. Sometimes a serpent was depicted on the front of a diamond line bracelet. A snake created by Cartier in 1919 was wildly different from the vast majority of diamond jewelry at the time, which typically featured bows, swags, and flowers. The necklace hinted at the exoticism to come in Cartier's Art Deco designs. It was among the first large full-bodied animal jewels created by the French enterprise, which would go on to produce many snakes and routinely make animals a part of its high jewelry collections.

The design of Cartier's serpent necklace has an openwork scale motif rendered in a slight arc that gives a natural quality to the body and reveals a level of excellence in workmanship. A flat surface would have been much easier to manufacture. Platinum millegrain, or miniscule beads, a quintessential element in jewels of the era, lines the edges of the setting. The clasp is hidden at the point where the head and tail entwine.

RIGHT Snake Necklace by Cartier Paris, 1919. Diamonds and platinum.

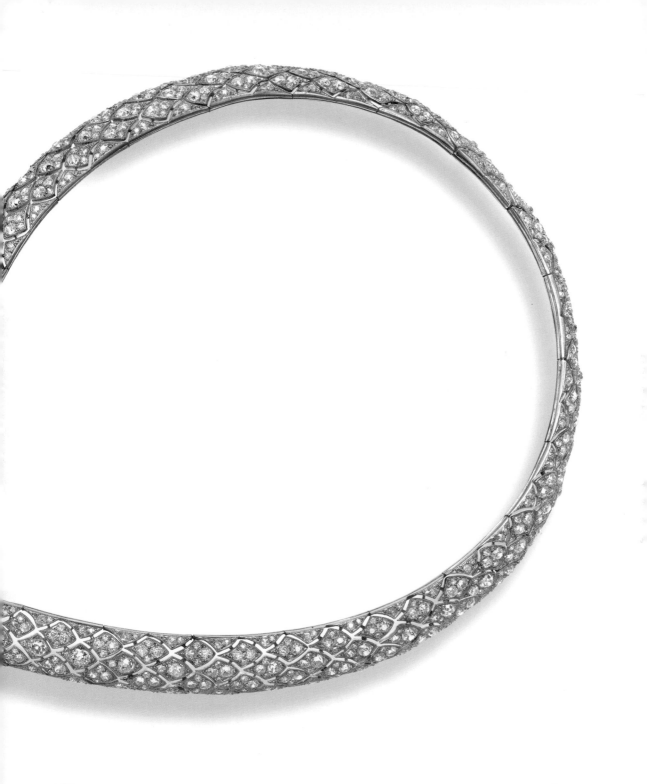

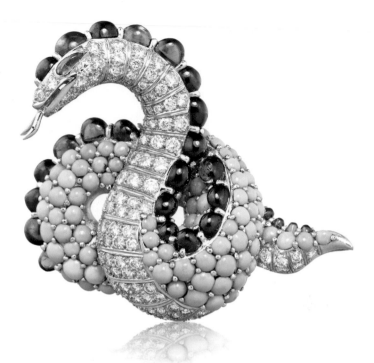

FROM THE 1920S through the 1940s, snakes remained scarce in jewels. Some designers started making them again in the 1950s. Cartier captured the spirit of the mid-century snake styles with a jewel that incorporated 19th-century elements on a larger scale. The double-headed triple-wrap snake bracelet, worn by model Charlotte Payne on a 1955 cover of *Vogue*, was set with marquise-shape coral and pearl accents.

· • · • ·

THERE WAS AN explosion of adventurous snake designs in the 1960s, when the creature enjoyed a cool factor that reflected the lifestyle of the period. Fulco di Verdura's cobra brooch is a perfect example. The designer positioned the snake with a coiled body and upright head as though poised in a dance for a snake charmer. Verdura made exquisite use of colorful gems on the pavé-set diamond jewel: cabochon sapphires line the back, cabochon turquoise covers the side of the serpent, and the eye sparkles with an elongated teardrop-shape emerald.

OPPOSITE Model Charlotte Payne wearing a pink sheath dress and cashmere sweater with coral, pearl, and diamond jewelry by Cartier, including a snake bracelet. Photo by Horst P. Horst for the cover of the April 15, 1955, issue of *Vogue*.

ABOVE Snake Brooch by Verdura, 1967. Sapphires, diamonds, turquoise, emerald (eye), platinum, and gold.

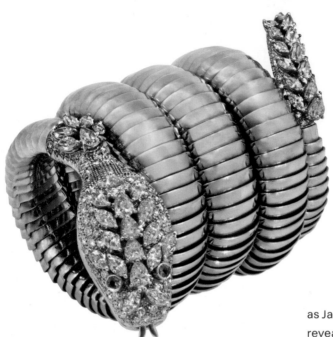

ABOVE Serpenti
Watch-Bracelet
by Bulgari, ca. 1967.
Diamonds, emeralds
(eyes), and gold.

OPPOSITE Elizabeth
Taylor wearing her
snake bracelet while
on the set of the film
Cleopatra, 1962.

FOR THE ITALIAN jeweler Bulgari, snake styles evolved into a house signature. The movement unofficially began in 1962, when Elizabeth Taylor posed for a photograph on the set of *Cleopatra* wearing her Bulgari snake bracelet. The image became part of the barrage of press surrounding the film's production after Taylor's affair with her leading man, Richard Burton, was made public.

Of all the amazing Bulgari jewels Burton gave Taylor, it is not certain that the snake bracelet was among them. The firm's ledger lists the date the piece was purchased as January 30, 1962, but does not reveal the client's name. There are additional elements of intrigue. Both actors were married when their affair began, and Taylor's husband, the American singer Eddie Fisher, also shopped for her at Bulgari and could have purchased the snake bracelet. Then again, Taylor might have bought the jewel for herself to celebrate her million-dollar contract for *Cleopatra*, the highest salary ever paid to an actress at the time. It's also possible the bracelet was a perk in her contract (Taylor often required a jewelry gift as a signing bonus). Since she did not wear the snake bracelet in the film, she may have worn it for this photo as a thank-you memento for the producers.

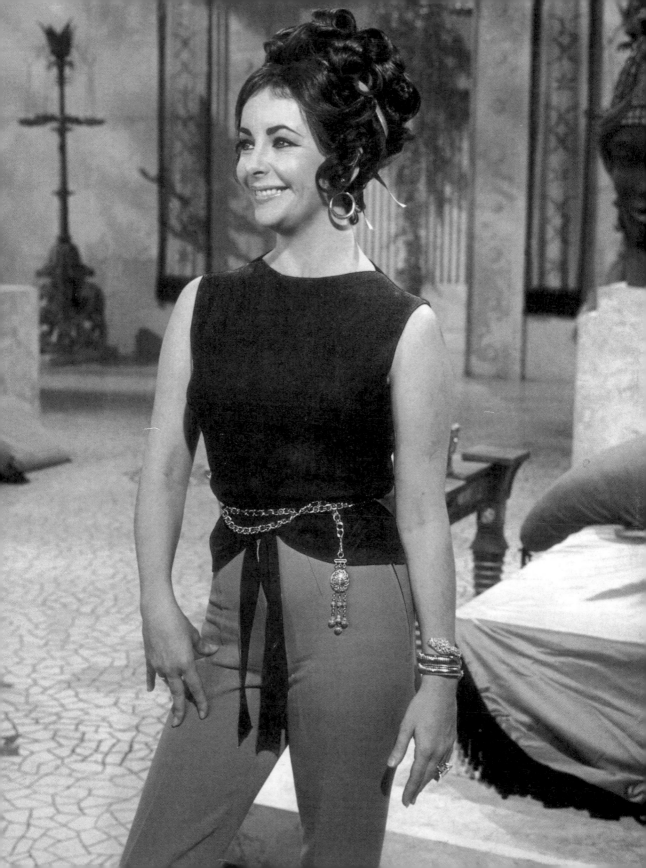

ABOVE Serpenti
Watch-Bracelet
by Bulgari, ca. 1967.
Diamonds, sapphire,
emeralds (eyes),
and gold.

ELIZABETH TAYLOR'S bracelet is a glorious example of the one-of-a-kind bracelets Bulgari designed in the 1960s. These snakes had diamonds in various shapes on the tails and heads. Some had additional diamonds on their gold bodies, as well as ruby, emerald, or sapphire accents. Various precious stones sparkled in the eyes. Fork-shape tongues extended ever so slightly out of the mouths.

Serpenti jewels were typically shaped using one of two different types of goldwork on the bodies: tubogas or tubolare. Tubogas goldwork resembles the surface of a midcentury gas pipe. Making it involves wrapping a gold strip with raised edges around a core of wood or copper; it all links together without solder and the core is removed or dissolved when it is complete. For tubolare goldwork, slender, tapered gold pentagons are hinged together to approximate the look of scales. Whether the tubogas or tubolare technique is employed, a white-gold spring is placed inside. The apparatus's flexibility allows the jewel to cling gently to the wrist for a perfect fit.

Most of these Bulgari snake bracelets have hinged jaws that open to reveal circular watch dials. In the 1960s, Bulgari partnered with such fine Swiss watchmakers as Jaeger-LeCoultre and Vacheron Constantin on the movements. The jeweler and watchmaker names usually appeared together on the watch dial.

ABOVE LEFT
Serpenti Watch-
Bracelet by Bulgari,
ca. 1965. Lapis lazuli,
turquoise, diamonds
(eyes), and gold.

ABOVE RIGHT
Serpenti Watch-
Bracelet by Bulgari,
ca. 1965. Pink coral,
orange coral,
emeralds (eyes),
and gold.

AROUND 1965 Bulgari introduced colorful snake bracelets that matched the vibrant fashions of the period. The youthful spirit in the air was present in the jeweler's office in Rome where the three young Bulgari brothers began running the firm shortly before their father passed away in early 1966. Gianni Bulgari, at 29, was the oldest. Paolo was 27 and Nicola was just 23. Together they electrified Bulgari, making jewelry that captured the essence of their generation.

The new wave of snake bracelets maintained the primary ingredients of the early 1960s jewels, but the exteriors changed. Opaque gemstones, such as coral, turquoise, and lapis lazuli, were used to form the scales of the entire body on some. Each gem had to be cut in elongated pentagons (for the body) or hexagons (for the head). Cutting stones to fit into a jewel, so that they can never be disassembled and used for another creation, is the apotheosis of creative jewelry design. While coral, turquoise, and lapis are not the most expensive gems devoted to the eternal life of a jewel, cutting them in this way heightened the aesthetics and value of the pieces.

Bulgari's snakes received a boost in the press in the United States when *Vogue* editor-in-chief Diana Vreeland dashed off one of her infamous staff memos on September 16, 1968, with the subject line "Serpents." It reads:

Don't forget the Serpent...
The serpent should be on every finger and all wrists and all everywhere...
The serpent is the motif of the hours in jewellery...
We cannot see enough of them...

COLORFUL ENAMEL bracelets were the best-known Bulgari Serpenti 1960s style. The pieces echo the enamel snake bracelets of the 19th century, but the Bulgari designs are more sophisticated in their conception and execution. The coloration of some of Bulgari's enamel snake jewels was inspired by actual species. Their names were subtly engraved in Italian on the tails. A polychromatic milk snake (*serpente del latte*) influenced the vivid pattern of blue, red, and black on one bracelet. The saddle of a long-nosed snake (*serpente nasuto*) became a bracelet's kaleidoscopic white, red, green, black, brown, and turquoise enamel scales. Other enamel snake bracelets featured colors found in fashion rather than in nature.

Once Vreeland issued her opinion, Bulgari snakes were featured in *Vogue* stories for years. Evidence of Vreeland's deep appreciation for the Bulgari gold and enamel snakes extended to her well-edited personal jewelry collection. She had a rare white enamel and gold snake belt with sapphire eyes. Measuring over 30 inches in length, the jewel was designed to be wrapped around the upper waist. Vreeland, however, preferred to style the belt dramatically as a necklace, twisting it twice around her throat.

OPPOSITE Model Benedetta Barzini wearing a couple of Bulgari Serpenti watch-bracelets and a belt. Photo by Gian Paolo Barbieri for the September 15, 1968, issue of *Vogue*.

OPPOSITE Snake
Necklace by Cartier
Paris, 1968. Diamonds,
emeralds (eyes),
platinum, enamel,
white gold, and
yellow gold. Formerly
in the collection of
María Félix.

MEXICAN ACTRESS María Félix clearly identified with snakes as symbols of wisdom and strength. Called "the supreme goddess of Spanish language cinema" by the *New York Times,* Félix made 47 films. She was nicknamed La Doña after playing the title role in *Doña Bárbara* (1943), about a strong, independent woman. Félix purposely never learned English and refused to appear in Hollywood productions to avoid being typecast. She did, however, learn French and starred in a handful of French films. Nobel Prize–winning Mexican poet Octavio Paz wrote about the actress, "She's free like the wind, she disperses the clouds, or illuminates them with the lightning flash of her gaze." Félix was painted several times by Mexican master Diego Rivera, who knew she loved snakes and gave her several live serpents.

In the 1950s, Félix had 52 turquoise 19th-century snake necklaces and bracelets in her collection. She often wore several at the same time. Her style grew even bolder in the mid-1960s, when her main residence was in Paris with her fourth and final husband, a Swiss businessman named Alex Berger. Around 1966 Félix visited Cartier and commissioned a large snake necklace.

The design and manufacture of the 22-inch, one-of-a-kind serpent took two years. A good portion of the time was most likely spent figuring out how to engineer the platinum and gold armature that made the necklace fully flexible. Cartier's master craftsmen also had to create a method for covering the snake's sinuous body in diamonds. There are 2,473 brilliant and baguette-cut diamonds on the necklace, weighing a total of 178.21 carats. Traditional jewels from India have decorative enamel

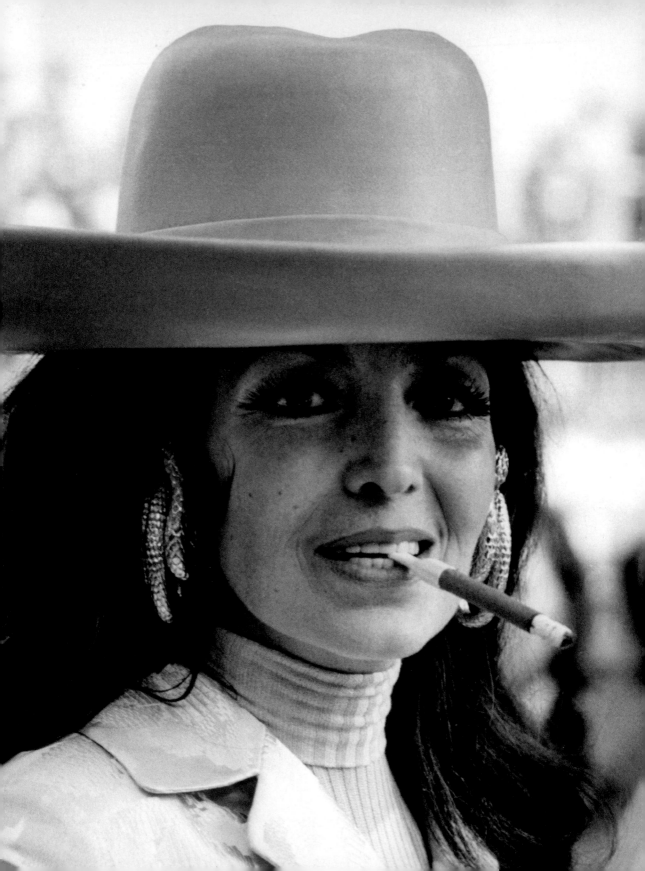

on the backs, and in a similar move the scales on the bottom of Félix's snake were painted with green, black, and red enamel—a nod to the colors of the Mexican flag. A removable pin operates as the clasp that holds the tail and head together. The jewel is unique in the Cartier menagerie of refined animals.

A few years after Félix acquired the snake necklace,

she commissioned a supersize pair of gold hoop earrings with turquoise-colored enamel covering the scales on the heads and the tips of the tails, and rubies and diamonds for the eyes. The jewels highlighted Félix's strong sense of personal style, which in turn heightened the drama of the French jeweler's creations.

OPPOSITE María Félix wearing her Cartier snake earrings at a horse race in Paris, 1972.

ABOVE Snake Ear Clips by Cartier Paris, 1971. Rubies (eyes), diamonds (eyes), enamel, yellow gold, and pink gold. Formerly in the collection of María Félix.

DUDULE WAS THE nickname that beloved French actress and renowned modern art collector Jacqueline Delubac gave the JAR serpent necklace she acquired around 1990 when she was in her eighties. The charming and tender moniker, a proper French name, could have been something Delubac conjured as a play on her own last name. It is also quite possible she commissioned the snake. The fact that Dudule is one of the few snakes JAR designer, Joel Arthur Rosenthal, has ever created suggests that it may have been a special order.

The JAR snake, which is hinged in the back so that it can be opened and placed around the neck, has all the designer's signature details. The setting is silver and gold in a style similar to 19th-century jewelry designs. The gems are a blend of precious and semiprecious stones used in a painterly way. For the scales, pavé-set white diamonds are interspersed with pavé-set sapphires. Large vari-cut amethysts cover the top of the serpent. A circular-cut sapphire is at the center of the head. The creature has cabochon sapphire eyes.

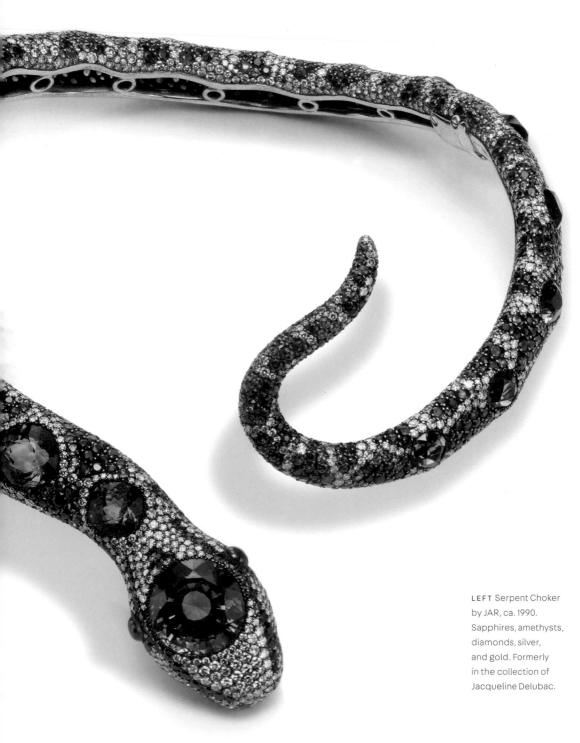

LEFT Serpent Choker
by JAR, ca. 1990.
Sapphires, amethysts,
diamonds, silver,
and gold. Formerly
in the collection of
Jacqueline Delubac.

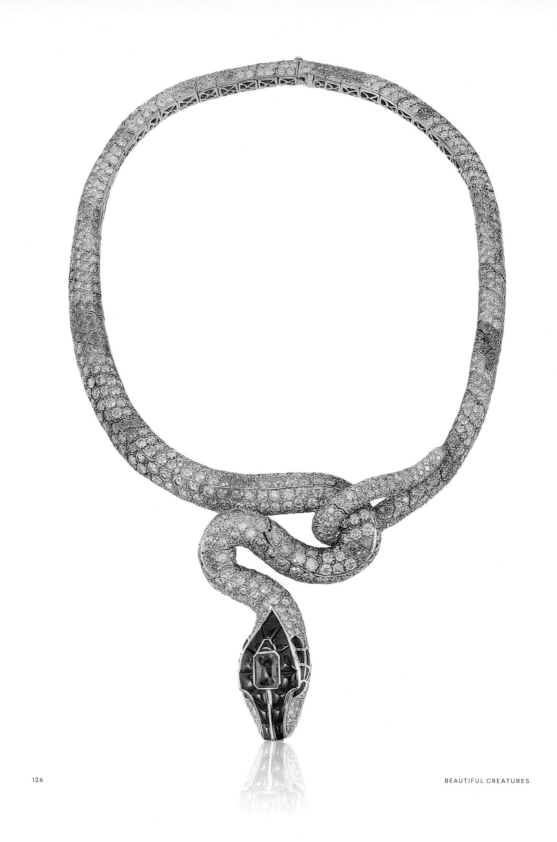

IN THE 1990S, when colored gemstone dealer Ralph Esmerian and master jeweler André Chervin, a co-founder of Carvin French, got together for one of their regular meetings, the discussion sometimes turned into a design collaboration. It usually started when Esmerian had some exceptional gems and a great idea for a jewel. "A designer has ideas and makes sketches, then finds the gems," Esmerian explains. "But a jeweler takes the opposite road: a jeweler buys the stones first and then realizes there is a jewel—it arises from the gemstones."

Several of the pieces Esmerian and Chervin created together were tributes to animal jewels of the past. In the mid-1990s, when Esmerian had a collection of pink diamonds from the Argyle mines in Australia, he told Chervin they could be made into a mother-and-child flamingo brooch. "It was initially inspired by the Duchess of Windsor's famous Cartier flamingo," Esmerian says. "The child was added to infuse a sense of compassion to the piece."

This snake necklace started with a collection of Esmerian's fancy colored yellow diamonds. The gem dealer said that María Félix's Cartier serpent necklace (page 121) sparked the idea of transforming them into a snake. While the Esmerian-Carvin French jewel is not fully flexible like the film star's snake, there is an elegant sense of movement at the front of the necklace. "The curl was important in order to break up the straight line of the snake," says Esmerian. The body is covered in fancy colored yellow diamonds. A bit of texture was added with large sections of brownish yellow diamonds. The head has specially cut buff-top rubies surrounding an emerald. "It took almost three years to make the piece, because the manufacturing process was intensive and we ended up needing more fancy colored diamonds than we had originally thought," explains Esmerian. "To find the stones that matched the ones we already had took time."

OPPOSITE Serpent Necklace by Ralph Esmerian & Carvin French for R. Esmerian, Inc., 1990. Colored diamonds, emeralds, rubies, and gold.

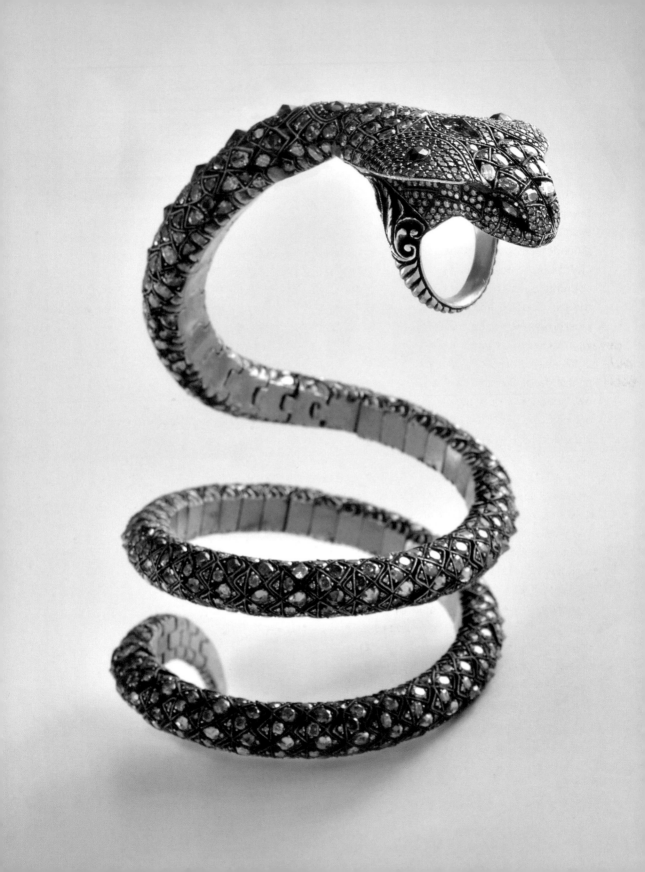

THE COBRA CUFF made by Sevan Biçakçi in 2011 is a shining example of the Turkish designer's groundbreaking work. A master craftsman, he began training as an apprentice in his native Istanbul at the age of twelve. Six years later, Biçakçi opened a shop creating wax models for other jewelers. In 2002, when Biçakçi turned thirty, he decided it was time to make his own collection. The traces of the ancient world and the Byzantine architecture surrounding Biçakçi in Turkey fed into his lavish narrative creations. His signature pieces are massive silver and 24-karat gold rings set with reverse carved intaglios depicting landmarks such as the Hagia Sophia and the Blue Mosque. Birds that fly around the city and were a symbol of freedom in Ottoman culture have also been frequent subjects of his carved rings. Biçakçi's singular style and his studio, located adjacent to the Grand Bazaar in Istanbul, have been covered heavily by the international press and caught the attention of high-profile jewelry collectors, including Gwyneth Paltrow, Brooke Shields, and Tory Burch.

Serpents from the ancient world inspired this cuff in the shape of a king cobra. Biçakçi was enchanted with the serpent that accompanied the ancient Greek goddess of the harvest, Demeter, and also drew on the snake emblem of his father's ancestors from the ancient Odzinsti tribe in eastern Turkey. The cuff is composed of 24-karat gold on the bottom of the snake. The silver on the top was decorated with a number of techniques to enhance the snakeskin texture. A multitude of white, yellow, brown, and black diamonds, totaling 67.48 carats, give color to the scales. The jewel is designed so the gaping jaws fit over a finger, and the body goes down the hand and wraps around the wrist. "Figuring out the articulation of the piece and the ergonomics were the most difficult part of the design," explains Biçakçi.

OPPOSITE King Cobra Cuff by Sevan Biçakçi, 2011. Diamonds, colored diamonds, gold, and silver.

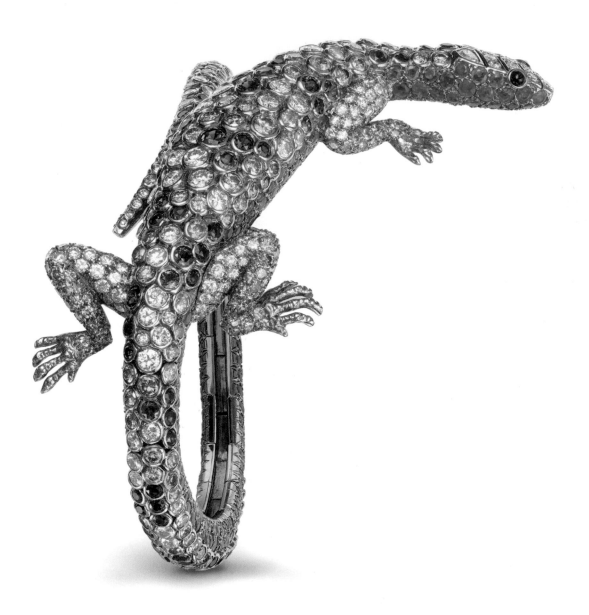

LIZARDS AND salamanders are similar in appearance, but come from different parts of the animal kingdom. Lizards are reptiles. Salamanders are amphibians that prefer humid environments, often on land near a water source. In jewelry, however, the animals share the same symbolism. Both bear a resemblance to mythical creatures, such as dragons or chimeras. Their ability to regenerate limbs or tails has made them emblems of renewal and transformation. From the 1880s to around 1910, there was a widespread fashion for little demantoid garnet salamanders and lizard daytime brooches. Beyond that era, they have only sporadically popped up in jewelry design.

·•·•·•·

IN 1972, Cartier made a special lizard bracelet that is designed so that the body of the sculptural creature sits on top of the wrist and the tail wraps around it. The scaly surface on the body and tail have a random pattern of bezel-set round sapphires and white and fancy yellow diamonds. A chevron pattern of round and pear-shape diamonds decorates the head. Emeralds cover the sides. The eyes are cabochon rubies, and the digits on the gold feet are sculpted to look realistic. The jewel was made a couple of years before María Félix's famous crocodile necklace (page 99). The two share some similarities in design, such as the position of the legs and feet.

Cartier's lizard bracelet was owned by Josette Day, the French actress famous for her leading role opposite Jean Marais in Jean Cocteau's 1946 romantic fantasy *Beauty and the Beast*. Four years later, at age 36, she retired from acting after marrying businessman Maurice Solvay. A great fan of animal jewelry, Day accumulated a collection of Cartier pieces. In addition to the lizard she had a pair of coral butterfly clips made in 1945.

OPPOSITE Lizard Bangle by Cartier Paris, 1972. Yellow diamonds, diamonds, emeralds, sapphires, rubies (eyes), and gold. Formerly in the collection of Josette Day.

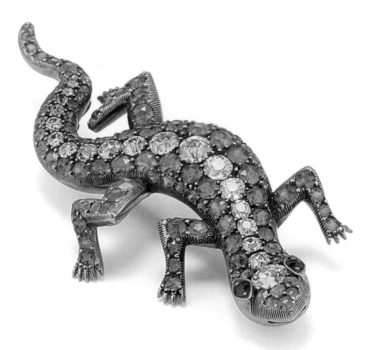

LIZARD AND salamander jewels made around the turn of the 20th century were directly linked to the 1864 announcement of the discovery of bright green demantoid garnets in Russia's Ural Mountains. The gems started flowing into markets in the West, where they were valued for a brilliance on par with that of diamonds. This quality inspired the name for the stones, which stems from the old German word *demant*, or diamond.

While demantoid garnets can be found in a variety of small animal scatter pins that were worn by women on their jackets to hold down scarves, they were most often used for lizards and salamanders. What spurred the popularity of these creatures at the time is unknown. It is clear, however, they were part of the general rise of animal jewels and were made throughout the Western world in a similar mode.

The curved bodies and tails of the little reptile and amphibian pins suggest movement. Diamonds usually accent the designs. Some have pearls. The eyes are often set with rubies. Most demantoid salamander brooches have bodies composed of either gold or silver and gold.

ABOVE Salamander Brooch, ca. 1900. Demantoid garnets, diamonds, rubies (eyes), and gold.

OPPOSITE Lizard Brooch, ca. 1880. Demantoid garnets, diamonds, rubies (eyes), gold, and silver.

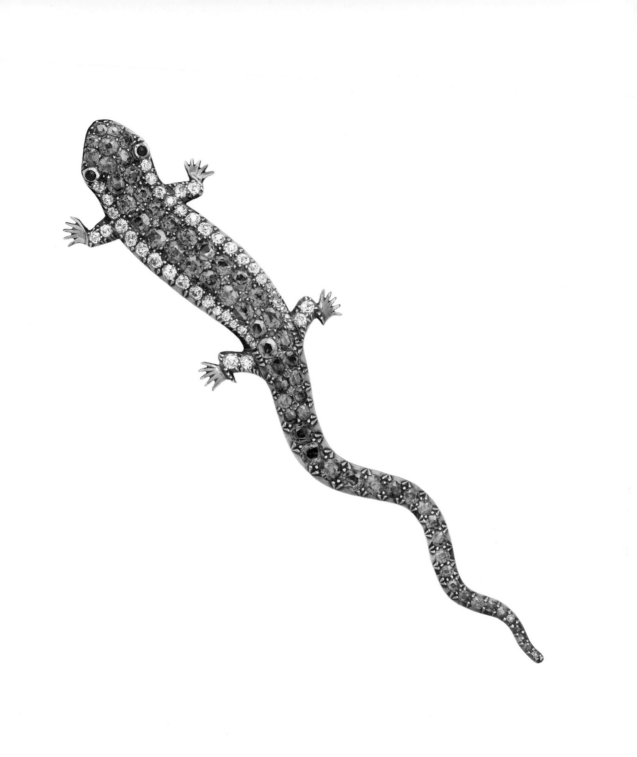

1.

1 a.

2. 2 a.

Prêtre pinx. *Borromée dir.* *Davesne sc.*

1. **Tortue sillonnée.** *Testudo sulcata.* *N.° 7, pag. 74, 2.° Volume.*

1 a. son Sternum.

2. **Pyxide arachnoïde.** *Pyxis arachnoïdes.* *N.° 1, pag. 136, 2.° Vol.*

2 a. la même vue en dessous.

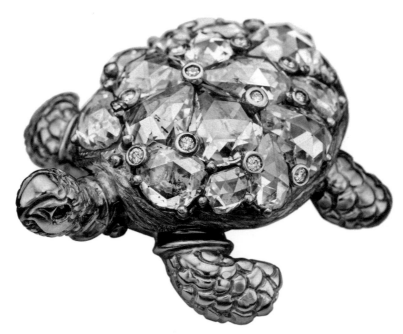

THE ENDEARING TORTOISE is a symbol of protection, longevity, and perseverance. While tortoises may not project the glamour of butterflies, they share with those insects a simple body shape that is relatively easy for designers to recreate in jewels. Over the years, tortoises have been depicted in small brooches, pendants, rings, earrings, and bracelets. The most impressive tortoise jewels use the creatures' shells as canvases for interesting gems.

ONE GOLD TORTOISE brooch made during the early years of the 20th century was transformed into treasure with substantially sized rose-cut diamonds. The facets on top of the oval, pear, and round gems cleverly imitate the texture of a tortoise's shell. Small bezel-set diamonds are interspersed among the larger gems. Engraved gold forms wrinkly skin on the feet and claws. The head is sculptural and fully out of the shell.

OPPOSITE. Illustration of an African spurred tortoise and a spider tortoise from André Marie Constant Duméril's *General Herpetology, or a Complete Natural History of Reptiles*, 1834.

ABOVE Tortoise Brooch, French, ca. 1900. Diamonds, rubies (eyes), gold, and platinum.

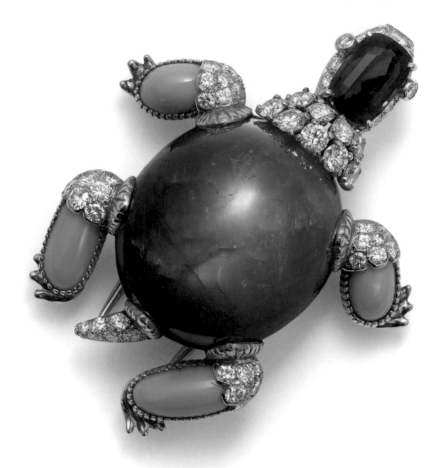

ABOVE Tortoise Clip
Brooch by Cartier
Paris, 1962. Sapphires,
diamonds, turquoise,
platinum, and gold.

OPPOSITE Tortoise
Brooch by David
Webb, 1971. Nephrite,
rubies, sapphires,
emeralds, and gold.

TORTOISES HAVE long been part
of Cartier's expansive menagerie.
Many of the firm's tortoise
designs are small pieces made of
semiprecious gems and gold. In
1962 Cartier reimagined the humble
tortoise as an important jewel.
Elegant but playful, the tortoise
epitomized the vibrant formal
jewelry of the era. An astonishing
93.14-carat star sapphire cabochon
forms the entire shell of the
creature. (Star sapphires contain
rutile fibers that reflect light in
three white bands that move when
the stone is viewed at different
angles.)The feet have elongated
turquoise cabochons highlighted
with diamonds and set in chased
and twisted gold mounting. A
cushion-cut sapphire surrounded
by diamonds forms the head.

TORTOISES ARE among the many animals in David Webb's jewelry collection. One of his most impressive was made in 1971 and reflects his passion for Eastern cultures. The brooch somewhat resembles the cover image of a turtle on a publication in the designer's reference library titled *A Book of Chinese Art: Four Thousand Years of Sculpture, Painting, Bronze, Jade, Lacquer, and Porcelain* by Lubor Hájek and Werner Forman (London: Spring Books, 1966). Webb's rendition centers on an oval piece of carved white nephrite. Like so many of the carved gems in Webb's jewels, the nephrite was antique; it came from a vintage piece of jewelry or perhaps a belt. The stylized body of the tortoise has a textured bold surface accented with sapphire and ruby cabochons. Emerald cabochons form the eyes. Facetted emeralds highlight the claws.

spiders

DEPICTIONS OF SPIDERS in late 19th-century jewelry reflected a popular interest in entomology. Spider scatter pins were the most common form of the arachnid in jewelry. Some spider jewels depict a creature set on top of a diamond web. The additional element may have been included for symbolic as well as aesthetic reasons. Spiders were considered an emblem of patience and perseverance, since they wait for prey to be trapped in their carefully spun webs. Over time, like so many 19th-century motifs, spiders transitioned into the repertoire of animals designers returned to repeatedly.

·•·•·•·

IN 1995 HEMMERLE created an impressive tarantula brooch that measures nearly six inches wide by six inches high. The tarantula was part of a series of nature-themed jewels the family-owned German firm created between 1979 and 1996. The idea of the tarantula stemmed from the spiders Stefan Hemmerle

and his teenage son, Christian, enjoyed studying at exhibitions around Munich, including those at the Museum of Man and Nature. "I was fascinated by spiders at the time," recalls Christian.

When a pearl dealer brought a 111.76-carat brown horse conch pearl to Stefan Hemmerle, he knew immediately that it would be perfect for the opisthosoma (abdomen) on the posterior of a tarantula brooch. Hemmerle conceived the exceptional jewel around the stunning pearl, which had been discovered in the ocean by a diver (as opposed to cultivated on a pearl farm). It is believed to be one of the largest, if not *the* largest, horse conch pearls in the world.

For the spider's prosoma (head and chest), Hemmerle used 39.84 carats of specially cut Umba sapphires from Tanzania. All eight of the tarantula's legs, as well as the two pedipalps with fangs at the front (used by the spiders for moving and eating), are made of gold and diamonds. The metal is textured in

OPPOSITE
Tarantula Brooch by Hemmerle, 1995. Horse conch pearl, Umba sapphires, diamonds, colored diamonds, and gold.

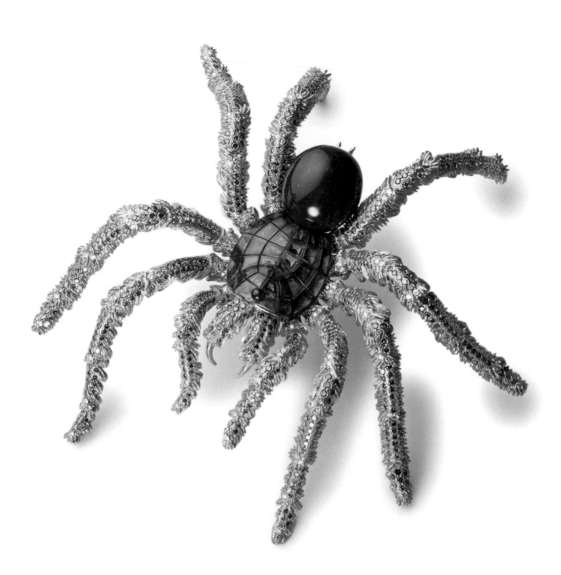

a way that imitates the bristles on the creature's appendages.

Hemmerle has kept the tarantula in its permanent collection as a masterpiece that reflects the ideals of the house: imaginative design, excellent craftsmanship, and superior gemstones. The jewel has been displayed in several museum exhibitions around the world, including the 2002 traveling exhibition *Pearls* that originated at the American Museum of Natural History and the 2013 exhibition *Pearls* at the Victoria & Albert Museum.

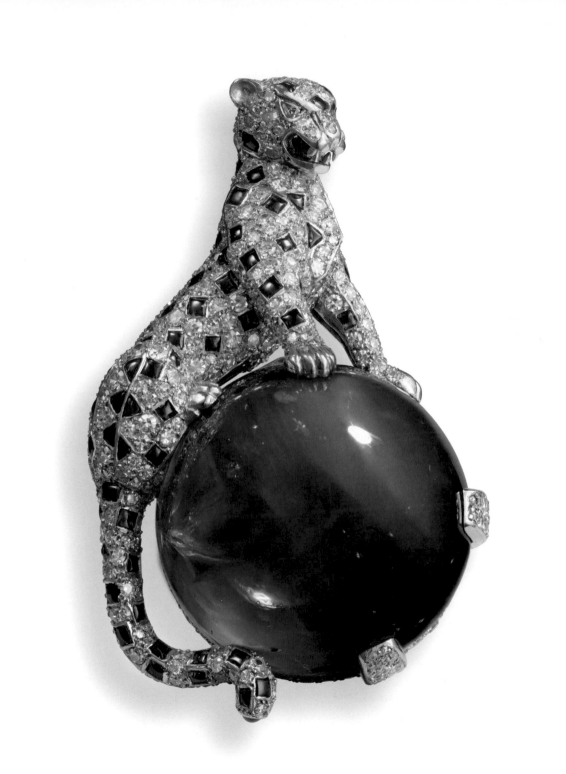

ONE OF THE SLEEKEST beasts in the animal jewelry kingdom, panthers have been prowling around the Cartier design studio for more than 100 years and are the unofficial mascot of the house. The first sign of the cat at Cartier was the creature's spots, which were depicted in onyx on a diamond wristwatch in 1914; the spots appeared again on a chatelaine watch the following year. It is believed the timepieces were conceived by the firm's talented designer Charles Jacqueau. In 1917 the first full-bodied panther, made of diamond and onyx, slinked between two cypress trees on an onyx vanity case. Significantly, the accessory was a special order placed by Louis Cartier, a member of the third generation of the family to run the firm.

Louis Cartier gave the panther vanity case to Jeanne Toussaint, a woman he greatly admired. The jewelry executive's nickname for the inventive, sharp-witted, and steely Toussaint was *La Panthère*. It is widely believed that Cartier and Toussaint were having an affair, so it's possible the gift was a romantic one. It also could have been part of Cartier's effort to persuade the visionary Toussaint, who was making handbags at another luxury label, to work for him. Toussaint joined Cartier in the early 1920s. Initially she oversaw the leather goods department, and later she moved over to run what was known as Department S (for silver).

In the 1920s, Cartier continued to make small panther jewels. One of the most charming pieces was a little brooch of a diamond and

OPPOSITE Panther Clip Brooch by Cartier Paris, 1949. Kashmir sapphire, diamonds, sapphires, yellow diamonds (eyes), platinum, and white gold. Formerly in the collection of the Duchess of Windsor.

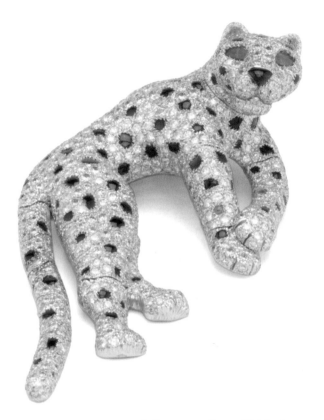

from the first ink-and-gouache design to the final polishing. Louis Cartier advised Toussaint not to learn to draw, as he believed that if she mastered the skill it would diminish her ability to critique the sketches of others. Toussaint worked closely on many animal jewels with the Cartier designer Peter Lemarchand, who spent time studying panthers at the Vincennes Zoo after it opened in Paris in 1934. He also used the scrapbooks and publications on animals in the Cartier reference library, including the bestseller *The Study of Animals* by author, naturalist painter, and illustrator Mathurin Méheut.

platinum panther with black enamel spots resting on an agate and onyx pedestal. It was purchased by the great American boxer Gene Tunney for his wife, Connecticut-born socialite Polly Lauder.

The scale of the panthers began to grow during the 1930s, around the period when Louis Cartier made Jeanne Toussaint the creative director of high jewelry. She supervised the predominantly male staff and every phase of production,

In the late 1940s, a new generation of panthers was born, and the Duke of Windsor commissioned one of the first from the new pack. In 1948, Toussaint and Lemarchand transformed a 116.85-carat cabochon emerald the Duke brought to Cartier into a brooch with a yellow-gold cat

ABOVE Panther Brooch by Cartier Paris, 1970. Diamonds, onyx, emeralds (eyes), platinum, and white gold.

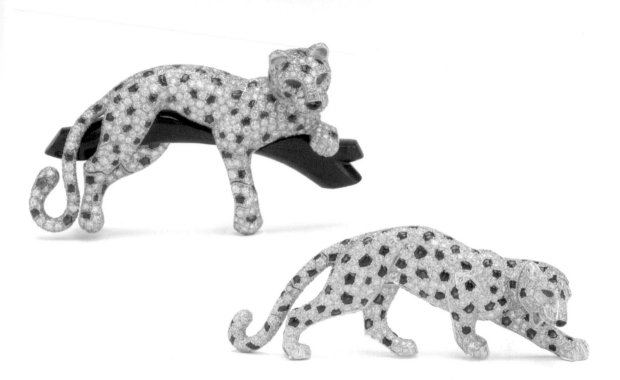

with black enamel spots seated on top. The Duchess of Windsor liked it so much that the Duke purchased another panther jewel in 1949 from Cartier stock (page 140). The iconic brooch features a 152.35-carat cabochon Kashmir sapphire with a growling panther perched on top. The fierce diamond and platinum cat has pear-shape yellow-diamond eyes and stylized cabochon sapphire spots.

There is a majestic quality to the panther and the round blue gem. It suggests the cat is on top of the world. The combination of the orb and panther is also reminiscent

of the first-century Albani lion sculpture with its paw resting on a sphere that is on display at the Louvre. The sculpture may have been a reference for Toussaint and her team of designers, who considered jewelry an art form. Toussaint told *Vogue* in 1964, "I live in museums."

After making the iconic cat, Toussaint unleashed a wide array of panther jewelry. She also added yellow-diamond and black-onyx tigers to the series. Solid hinged bracelets with two panthers or tigers recalled the silhouettes of lion-head

ABOVE LEFT
Panther on a
Branch Brooch
by Cartier Paris,
ca. 1988. Diamonds,
sapphires, emeralds
(eyes), lapis lazuli,
and gold.

ABOVE RIGHT
Panther Brooch
by Cartier, ca. 1990.
Diamonds, sapphires,
emeralds (eyes),
onyx, platinum, and
white gold.

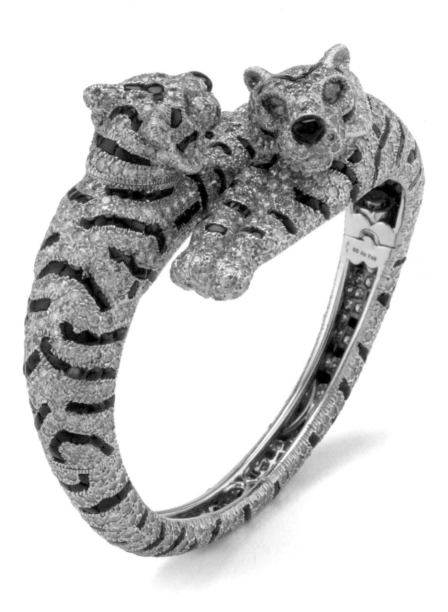

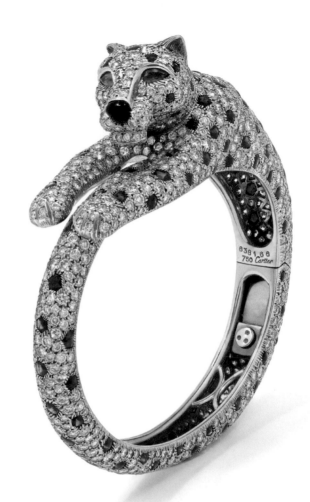

bracelets from ancient Greece. Certain brooches and earrings had panthers and tigers in a dangling posture, similar to the positioning of the sheepskin in the Golden Fleece, an emblem of an order of knights founded by Philip the Good of Burgundy in the 15th century.

Cartier's cats were immediately adopted by high-profile collectors. The Duchess of Windsor added several more panthers and a few tigers to her jewelry box. Nina Dyer had a litter of panther jewels commissioned by her husband, Prince Sadruddin Aga Khan, between 1957 and 1959. Daisy Fellowes commissioned a panther brooch in the position of the Order of the Golden Fleece in 1950. Barbara Hutton, the Woolworth heiress, had a family of tigers.

The craze for Cartier cats contributed to the widespread popularity of all animal jewelry. David Webb, who made animals central in his collections, tipped his hat to Toussaint. The American designer told *Vogue* in 1964, "It's completely Toussaint's influence,

of course—she is the inspiration of us all."

After Jeanne Toussaint retired in 1970 at age 83, Cartier continued to make panthers in the spirit of the style she pioneered. The many generations of Cartier panthers have transformed the creature into one of the most recognizable motifs in the history of jewelry.

OPPOSITE Tigers Bracelet by Cartier Paris, ca. 1990. Yellow diamonds, onyx, emeralds, and gold.

ABOVE Panther Bracelet by Cartier Paris, ca. 1985. Diamonds, sapphires, emeralds (eyes), onyx, and gold.

OPPOSITE Model wearing a diamond-and-sapphire Cartier Paris panther pinned to a coat. Photo by Arthur Elgort for the September 2004 issue of *Vogue*.

RIGHT Panther Pendant by Cartier Paris, designed in 2008. Diamonds, onyx, emeralds, platinum, and black silk cord.

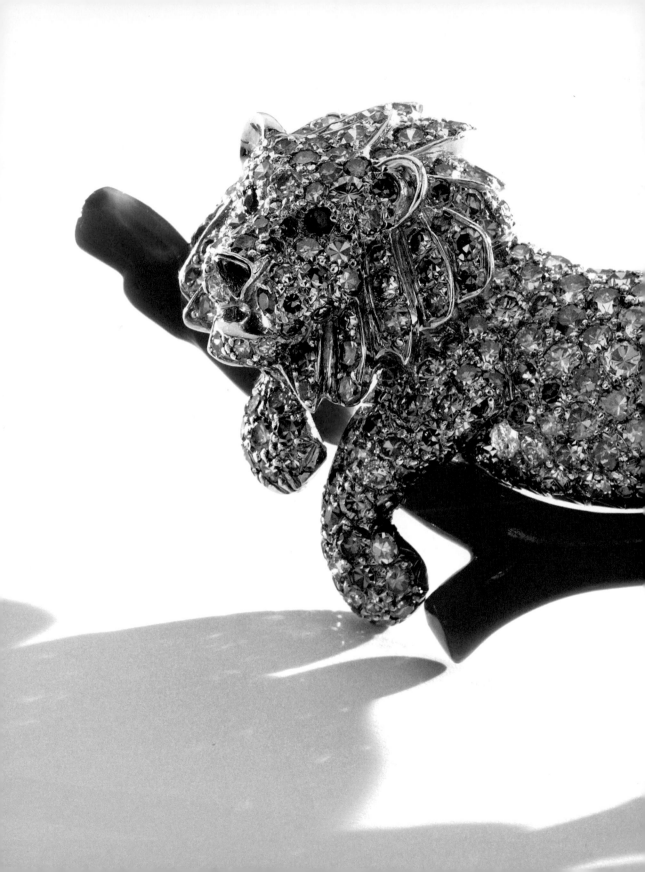

ELEPHANTS, GIRAFFES, lions, zebras, and other large mammals of Africa stampeded into fine jewelry collections in the 1960s and continued to roam through them in the 1970s. It was a period that saw widespread popularity of animals in jewelry, but these creatures were different. Giraffes and zebras were virtually unknown in jewelry up to that point. Elephant and lion jewels had appeared in styles mainly as cultural or artistic references to the past. During the late 19th century, for example, lion heads were depicted at the ends of open bracelets in the archeological revival mode of ancient Greek jewelry. Historically elephants in jewelry were often decorated in the image of the revered elephants of India, topped with *jhools* (saddlecloths) and howdahs (covered seating apparatus).

Many of the African mammal jewels of the 1960s and 1970s were more realistic and clearly connected to the beauty of animals in nature. What inspired designers to turn their gaze toward these amazing creatures? Conservationists seeking to protect the endangered elephants, among other animals in Africa, made the subject news. American photographer and artist Peter Beard became one of the most high-profile activists in 1965 when he published his seminal work *The End of the Game*, which documented the devastating effects—such as starvation and overpopulation—of various forms of human intervention and misguided conservation efforts aimed at protecting African wildlife. In 1966 the United States government passed the Endangered Species Preservation Act. The media surrounding these events put African mammals foremost in the minds of designers and their clientele.

elephants, giraffes, lions, and zebras

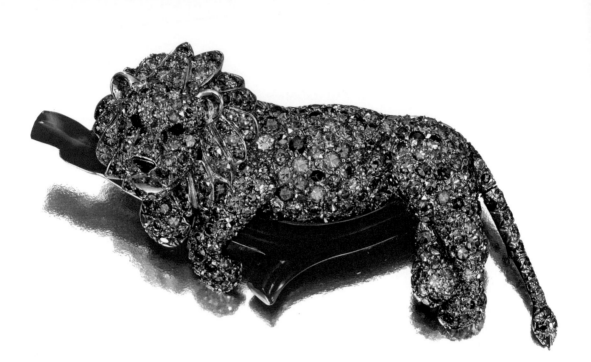

NEW YORK SOCIALITE Brooke Astor owned a glorious lion brooch made by Van Cleef & Arpels in 1968. The king of the jungle is resting on a coral branch with its hind legs crossed. Its tail is articulated. The body of the lion is covered in yellow diamonds in various shades that create a sense of texture and depth on the fur. Rubies form the eyes; black enamel decorates the nose.

The Astor family's connection to the New York Public Library in Manhattan has led to conjecture that the brooch might be linked to the world-renowned marble lions, known as Patience and Fortitude, that flank the main library's Fifth Avenue entrance. A gift to the library in 1911, the lion statues were once called Leo Astor and Leo Lenox after the founders, John Jacob Astor and James Lenox. Throughout her life, Brooke Astor continued her family's patronage of the institution. After the philanthropist passed away in 2007, the library posted a tribute on its website that reads in part, "No one in the modern history of the Library played a more pivotal role in promoting, and supporting, the welfare of the Library than Brooke Astor."

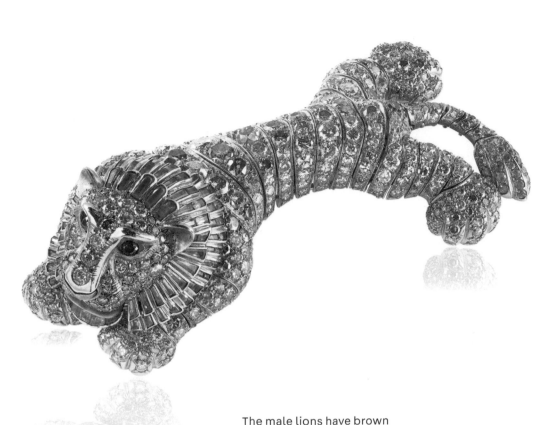

LIONS AND TIGERS became part of the menagerie in the René Boivin collection at the dawn of the 1960s. The most dramatic examples of the big cats were a limited series of brooches designed to be draped over women's shoulders. They are referred to as lion or tiger *couché* shoulder brooches. (*Couché* is the French verb for lying down.) Each was made of attached segments so it hugged the curves of the body.

The male lions have brown diamond eyes, various shades of yellow diamonds on the bodies, and emeralds on the manes and tips of the tails. The French jeweler's tigers were decorated with stripes of white, yellow, and orange diamonds. Hélène Rochas, the widow of French fashion designer Marcel Rochas, who worked as an executive running his fragrance business from the mid-1950s through 1970, owned a Boivin tiger shoulder brooch. It was the most original piece in her stunning jewelry collection.

ABOVE Lion Couché Shoulder Brooch by René Boivin, 1960. Colored diamonds, diamonds, emeralds, brown diamonds (eyes), and gold.

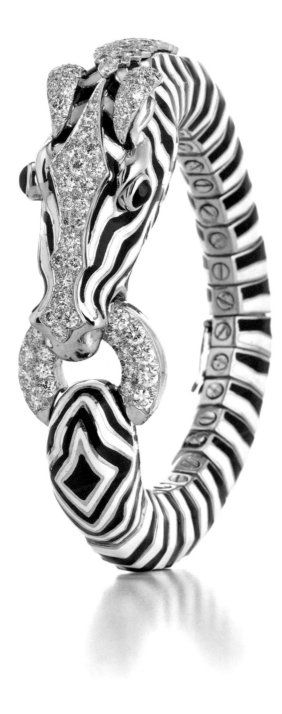

ALL KINDS OF AFRICAN mammals were part of the bracelet collection of David Webb, who won a prestigious Coty American Fashion Critics' Award in 1964. Among Webb's many animals, his zebras have become the most famous and are an unofficial mascot of the firm. The eye-catching graphic black-and-white champlevé enamel-and-gold zebra bracelet has a diamond mane and ears, as well as ruby eyes.

Vogue editor-in-chief Diana Vreeland acquired one of the first David Webb zebra bracelets and it became a signature of hers. She also had famed lensman Irving Penn photograph one for the March 1, 1964, issue of *Vogue*. The zebra bracelet's high status in the canon of great American jewelry was confirmed in 2018 when the Metropolitan Museum of Art in New York acquired one for its collection.

LEFT Zebra Bracelet by David Webb, designed in 1963, made in 2019. Diamonds, rubies (eyes), enamel, gold, and platinum.

OPPOSITE Marisa Berenson wearing gold-and-diamond animal bracelets by Tiffany & Co., including an elephant and an alligator. Photo by Bert Stern for the March 1, 1970, issue of *Vogue*.

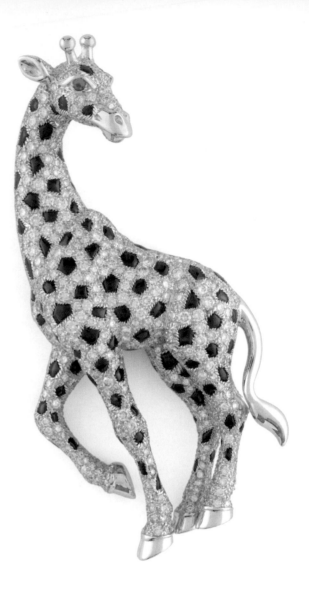

IN 1969 TIFFANY & CO. added a giraffe to its collection of gold animal bracelets that included an elephant, a tiger, and an alligator. All of them were sculptural gold jewels. The head of the giraffe jewel curls over the top and looks straight ahead with emerald eyes. A contrasting patch of hair on the gentle giant's head has diamonds set in platinum. The ears, nose, mane, and ossicones, or horn-like protuberances, are realistically sculpted in gold. The giraffe's spots, slightly elevated patches of shiny gold, wrap around the bracelet.

In the mid-1970s, Cartier made a series of giraffe brooches. Each of the styles showed the tall elegant mammal in a position that made it look like it was in motion, with one front leg bent at the knee, the tail turned up, and the head looking slightly back. Many of Cartier's giraffes came in yellow gold with brown enamel spots or diamonds with onyx spots. The most spectacular styles had pavé-set diamonds and sapphires in any number of shapes to suggest the unique pattern of spots on a giraffe. A pair of the giraffes—one gold and one diamond—were photographed for a 1979 French editorial in a setting that resembled the plains of Africa at sunset.

ABOVE Giraffe Brooch by Cartier Paris, ca. 1979. Diamonds, sapphires, emerald (eye), gold, and platinum.

OPPOSITE Giraffe Bracelet by Tiffany & Co., 1969. Diamonds, emeralds (eyes), and gold.

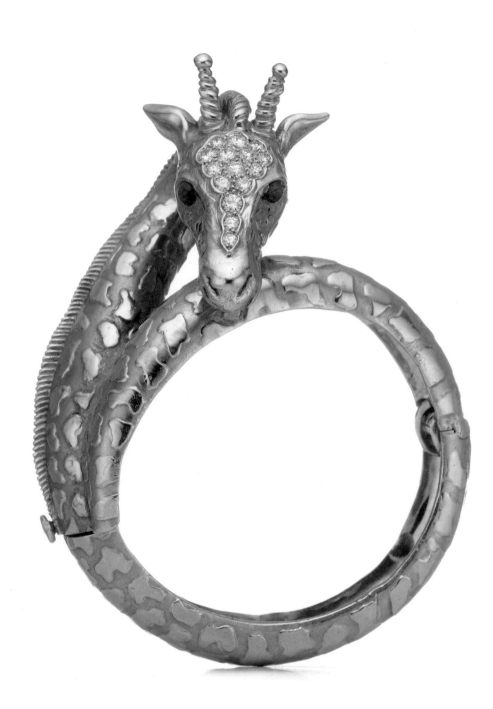

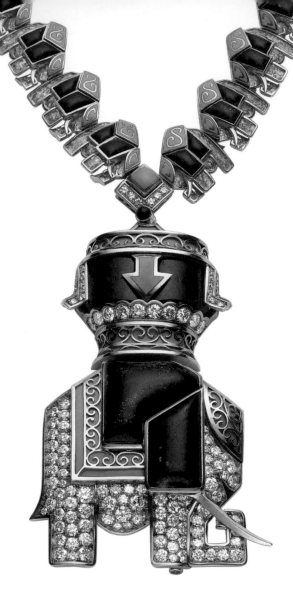

set with a sophisticated palette of cabochon shaped gems and ended in pendants, each with a large impressive gem. Bulgari used cabochons because the rounded shape gives a softer, more artistic appearance than faceted gems. Cabochons conjure up the creative pieces made during the Renaissance.

For the elephant sautoirs, Bulgari used specially cut gems with a rounded cabochon-style top. One elephant necklace is set with vibrant amethysts and green enamel. Another has lapis lazuli and a turquoise shade of enamel. Diamonds accent the elephant's body on the pendant. Textured gold forms the bodies of the herd of elephants on the necklace. Each creature in the parade has an Indian *jhool*, and the largest has a howdah. It has long been a tradition in jewelry to outfit elephant jewels in Indian attire.

BULGARI DEBUTED a series of sautoirs that included a parade of elephants in the late 1960s. The elephants were among the very few animals in the Italian jeweler's striking series. Most of the long necklaces, which measured 26 or 34 inches, were

ABOVE Elephant Pendant Necklace by Bulgari, ca. 1965. Lapis lazuli, diamonds, enamel, and gold.

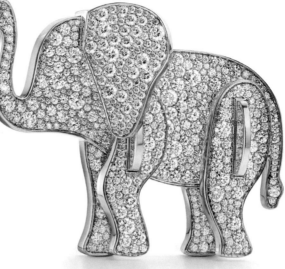

CONSERVATION OF ANIMALS in Africa, which made so much news during the 1960s and 1970s, has continued to be an important issue, and the animals are in even more dire straits today than they were back then. In 2017 elephant poaching, trafficking, and demand for ivory motivated Tiffany & Co. to launch the Save the Wild jewelry collection. One hundred percent of the net profit proceeds are donated to the Wildlife Conservation Network, which includes the Elephant Crisis Fund.

Animal jewels in the collection include pendants of elephants, lions, and rhinos made in silver, rose gold, and a combination of the two metals. The pieces resemble construction paper cutouts with flat surfaces that fit together. Special gold lion brooches have diamond accents. The most precious pieces are white gold elephant brooches covered in over 7 carats of diamonds.

Supermodel and animal rights activist Doutzen Kroes, who is an ambassador of the collection, has worn the diamond Save the Wild elephant brooch on several occasions, including for the July 2019 cover of *Elle* magazine. Her efforts have helped to bring awareness to the cause and to Tiffany & Co.'s charitable activities. In just under two years, the Save the Wild collection raised more than five million dollars for the Wildlife Conservation Network. It's a fitting tribute from a jeweler that has been inspired by the animal kingdom for more than 150 years.

ABOVE Save the Wild Elephant Brooch by Tiffany & Co., 2019. Diamonds and white gold.

ACKNOWLEDGMENTS

IT HAS BEEN A PLEASURE and a privilege to work with the talented team at the American Museum of Natural History on this catalogue for the *Beautiful Creatures* exhibition. First and foremost, I would like to thank George Harlow for his leadership. I could not have completed this book without the day-to-day guidance and brilliance of Melissa Posen and Stephanie Carson. I would also like to make special mention of Lauri Halderman, Joel Sweimler, José Ramos, Karen Miller, Sharon Stulberg, and Craig Chesek.

At Rizzoli, I owe a debt of gratitude to Margaret Chace for her enthusiastic embrace of the publication. I am deeply grateful to my editor Andrea Danese for her vision in shaping the format of this unique book. Sarah Gifford's imaginative design perfectly captures the joy of the jewelry.

To assemble *Beautiful Creatures*, I received generous assistance from collectors, curators, and experts. I am grateful to so many, including Peter Schaffer at A La Vieille Russie; Kazumi Arikawa and Keiko Horii at Albion Art Jewellery Institute; Dianne Batista; Gerald David Bauman; Hillary and Rusty Fogarty at Beladora; Nico Landrigan and Caroline Perkowski at Belperron; Hélène Poulit-Duquesne of Boucheron; Linda Buckley; Monica Brannetti at Bulgari Brand Heritage Department; Gus Davis at Camilla Dietz Bergeron; Catherine Cariou; Cartier Heritage teams in Geneva, Paris, and New York; Daphne Lingon at Christie's; Paula Crevoshay; Mark Emanuel and Levi Higgs at David Webb; Sarah Davis; Jim DeMattei; Carlo Eleuteri, Wagner Eleuteri, and Hilary Gurley of Eleuteri; Barbara Berkowitz and Tim Mendelson at Elizabeth Taylor/House of Taylor Companies; Ralph Esmerian; Benjamin Fadlun and Ester Fadlun; Lisa Maria Falcone; Fiona Druckenmiller and Fernando Bustillo at FD Gallery; Fine Emerald Inc.; Greg Kwiat and Rebecca Selva at Fred Leighton; Lionel Geneste; Bina Goenka; Audrey Gruss; Glenn Spiro; Christian Hemmerle; Judy and Greg Horrigan; Douglas Kazanjian and Joseph Barrios at Kazanjian; LA Collection Privée; Neil Lane; Guy Bedarida at Marina B; Pierce MacGuire; Bill and Nadine McGuire; Dennis Meyers; Laure-Isabelle Mellerio and Diane-Sophie Lanselle at Mellerio; Allison and Roberto Mignone; Rudi and Caryn Scheidt; Sevan Biçakçi and Emre Dilaver of Sevan Biçakçi; Quig Bruning and Frank Everett of Sotheby's; Anne-Marie Stanton; Shaye Strager; Suzanne Tannenbaum; Simon Teakle; Christopher Young, Annamarie Sandecki, and Nicole Ehrbar at Tiffany & Co.; Jennifer Tilly; Nicolas Bos and the patrimony teams of Van Cleef & Arpels in Paris and New York; Nishan Vartanian of Vartanian & Sons; Ward Landrigan and Caroline Packer at Verdura; Wallace Chan and Cherry Rao at Wallace Chan; Stephen and Assia Webster.

Marion Fasel
New York City, 2020

SELECT BIBLIOGRAPHY

Becker, Vivienne. *Cartier Panthère*. Assouline, 2015.

Boscaini, Lucia. *The Art of Bvlgari: 130 Years of Italian Masterpieces*. Houston Museum of Natural Science, 2014.

Chaille, François, Thierry Coudert, Violette Petit, Jenn Rourke, Michael Spink, and Christophe Vachaudez. *The Cartier Collection Jewelry Volumes 1 and 2*. Flammarion, 2019.

Coleno, Nadine. *Amazing Cartier: Creations since 1937*. Paris: Editions du Regard, 2008.

Corbett, Patricia. *Verdura: The Life and Work of a Master Jeweler*. Thames & Hudson, 2008.

Corbett, Patricia, Ward Landrigan, and Nico Landrigan. *Jewelry by Suzanne Belperron: My Style Is My Signature*. Thames & Hudson, 2015.

Fasel, Marion. *Bulgari: Serpenti Collection*. Assouline, 2013.

Loring, John. *Tiffany Fauna*. Abrams, 2003.

Nissenson, Marilyn, and Susan Jonas. *Jeweled Bugs And Butterflies*. Abrams, 2000.

Peltason, Ruth. *David Webb: The Quintessential American Jeweler*. Assouline, 2013.

Proddow, Penny, and Marion Fasel. *Bejeweled: Great Designers, Celebrity Style*. Abrams, 2001.

Proddow, Penny, and Marion Fasel. *Diamonds: A Century of Spectacular Jewels*. Abrams, 1996.

Tennenbaum, Suzanne, and Janet Zapata. *The Jeweled Menagerie: The World of Animals in Gems*. Thames & Hudson, 2007.

PHOTO CREDITS

Front cover, clockwise from top, center: Courtesy of L'ECOLE, School of Jewelry Arts, photo by Benjamin Chelly; Nils Herrmann, Collection Cartier © Cartier; © Sotheby's; C. Chesek/© AMNH; Tiffany & Co. Archives 2020; C. Chesek/© AMNH; Private Collection, courtesy Albion Art Jewellery Institute; Photo by David Behl. © Belperron, LLC; Courtesy Hemmerle; FD Gallery; Tiffany & Co. Archives 2020

Courtesy A La Vieille Russie: 86

Albion Art Collection: 55, 133, 135

Private Collection, courtesy Albion Art Jewellery Institute: 6, 49, 50

© AMNH: 134

Jake Armour, Armour Photography: 2–3, 28, 91

Marina B: 97

Gian Paolo Barbieri/Condé Nast/Getty Images: 118

Belperron Museum Collection. © Belperron, LLC: 18 (right)

From a private collection. Photo by David Behl. © Belperron, LLC: 18 (left)

From the collection of Rudi and Caryn Scheidt. Photo by David Behl. © Belperron, LLC: 19 (right)

From the collection of Judy and Greg Horrigan. Photo by David Behl. © Belperron, LLC: 19 (left)

From a private collection. © Belperron, LLC: 20

Bettmann/Getty Images: 34, 56 (left)

Kemal Olca for Sevan Biçakçi: 128

Boucheron: 48, 53, 66

Bulgari Historical Archive: 116, 117 (left)

Cartier Collection © Cartier: 56 (right), 58

Wallace Chan: 4, 29, 43

C. Chesek/© AMNH: 7, 8, 35, 42, 61, 75, 92, 132, 142, 143 (left), 144, 145, 147, 154

© 2009 Christie's Images: 90

© 2018 Christie's Images Limited: 151

Paula Crevoshay: 102–103

Courtesy Bulgari Historical Archive. Photo Studio Orizzonte: 156

Arthur Elgort/Condé Nast/Getty Images: 146

FD Gallery: 104–105, 124–25

Courtesy Fine Emerald, Inc: 126

Marian Gérard, Cartier Collection © Cartier: 160

Bina Goenka: 71

Tim Graham/Getty Images: 94

Courtesy Hemmerle: 70, 93, 139

Nils Herrmann, Cartier Collection © Cartier: 12, 13, 57, 99, 110–11, 123, 130, 136

Horst P. Horst/Condé Nast/Getty Images: 41, 87, 112

Jay-Z, courtesy Glenn Spiro: 32

© Keystone-France/GAMMA RAPHO: 122

Courtesy of L'ECOLE, School of Jewelry Arts, photo by Benjamin Chelly: 64, 65

Joseph Leombruno/Condé Nast/Getty Images: 21 (left)

Mellerio: 108

© Ministère de la Culture/Médiathèque du Patrimoine, Dist. RMN-Grand Palais/Art Resource, NY: 63

Franco Rubartelli/Getty Images: 23

La Presse, courtesy of Bulgari: 115

The Print Collector/Alamy Stock Photo: 17

John Rawlings/Condé Nast/Getty Images: 88

David Ross Photography/© AMNH: 10, 11, 14, 21 (right), 72–73, 89, 100, 106–107, 114, 117 (right), 143 (right)

© Sotheby's: 148, 150

© Sotheby's, private collection: 40

Glenn Spiro: 33

Bert Stern/Condé Nast/Getty Images: 68, 153

Jean Tesseyre/Paris Match/Getty Images: 77

Andrea Thompson Photography: 27

Tiffany & Co. Archives 2020: 24, 36, 39, 45, 46, 47, 67, 69, 95, 155, 157

© Van Cleef & Arpels SA: 51, 52

Verdura Archives. © Verdura: 79

Verdura Museum Collection. © Verdura: 22, 78, 85, 113

David Webb Heritage Collection, courtesy David Webb Archives: 81, 137

Courtesy David Webb New York: 80, 152

Courtesy David Webb New York, private collection: 25

Courtesy Stephen Webster: 82

Vincent Wulveryck, Collection Cartier © Cartier: 37, 59, 62, 121, 140

First published in the United States of America in 2020 by
Rizzoli Electa, A Division of
Rizzoli International Publications, Inc.
300 Park Avenue South
New York, NY 10010
www.rizzoliusa.com

Copyright © 2020 American Museum of Natural History
Foreword **ELLEN V. FUTTER**
Text **MARION FASEL**

Publisher **CHARLES MIERS**
Associate Publisher **MARGARET RENNOLDS CHACE**
Editor **ANDREA DANESE**
Designer **SARAH GIFFORD**
Production Manager **ALYN EVANS**
Managing Editor **LYNN SCRABIS**

All rights reserved. No part of this publication may be reproduced,
stored in a retrieval system, or transmitted in any form or by any
means, electronic, mechanical, photocopying, recording, or otherwise,
without prior consent of the publishers.

Printed in China

2021 2022 2023 2024 / 10 9 8 7 6 5 4 3 2

ISBN 978-0-8478-6840-7
Library of Congress Control Number: 2020938399

Visit us online:
Facebook.com/RizzoliNewYork
Twitter: @Rizzoli_Books
Instagram.com/RizzoliBooks
Pinterest.com/RizzoliBooks
Youtube.com/user/RizzoliNY
Issuu.com/Rizzoli

FRONT COVER, CLOCKWISE FROM TOP LEFT Serpent Choker by JAR, ca. 1990; Bee Pin by Tiffany & Co., ca. 1895; Exotic Bird Brooch by Sterlé, ca. 1960; half of the Crocodile Necklace, Cartier Paris, 1975; Lion Brooch by Van Cleef & Arpels, 1968; Redstart Clip by Boucheron, designed in 1956, made in 1988; Giraffe Bracelet by Tiffany & Co., 1969; Swallow Brooch, ca. 1910; Lizard Brooch, ca. 1880; Butterfly Brooch by Suzanne Belperron, ca. 1936; Gray Parrot Brooch by Hemmerle, 1997.

BACK COVER, BOTTOM LEFT Butterfly Brooch by Suzanne Belperron, ca. 1936; **UPPER RIGHT** Butterfly Brooch by JAR, 1987.

PAGE 1 Crocodile Necklace by Cartier Paris, 1975 (page 99).

PAGE 2 Étoile de Mer Brooch by Salvador Dalí, ca. 1950 (page 91).

PAGE 4 Forever Dancing–Bright Star Brooch by Wallace Chan, 2013 (page 31).

BELOW Snake Ring by Cartier Paris, 1966. Gold, platinum, diamonds, and emeralds (eyes). Formerly in the collection of Elizabeth Taylor.